IMAGES
of America

GRANVILLE

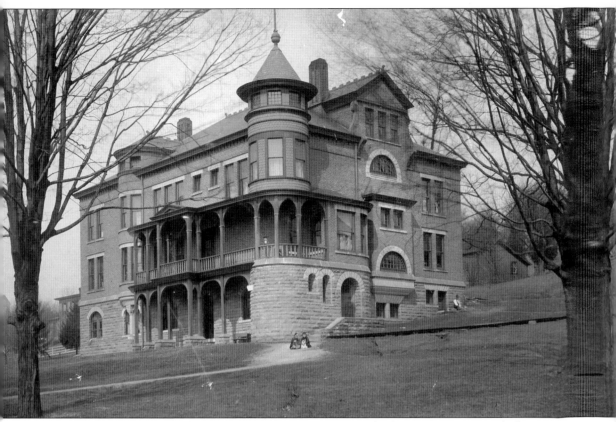

Burton Hall of Music on the Denison University campus was built in 1888. It is named after Dr. Nathan S. Burton, the founder of the Young Ladies' Institute, which became Shepardson College. Denison's music department now occupies the building, but it originally housed dormitories for the women of Shepardson. Fourth-floor dormers have been added to the original Queen Anne–style structure, but the building remains remarkably unchanged. In this photograph, taken soon after the building's construction, a couple of young ladies and an unidentified man relax on the dormitory lawn.

ON THE COVER: The cemetery where Granville's founders are buried is called the Old Colony Burying Ground. It is located very conspicuously on the east side of South Main Street. It was established in 1805, along with the rest of the town. Over the years, the burial ground became overgrown and neglected, and in 1992, an official campaign began to restore the cemetery to its original splendor. That job is still ongoing. Over the years, several groups attempted to maintain the burial ground. In this 1923 photograph, members of the Granville DAR and fellow volunteers, including Mayor John Graham, work to clean up the cemetery.

IMAGES
of America

GRANVILLE

Alexa McDonough and Theresa Overholser

ARCADIA
PUBLISHING

Copyright © 2013 by Alexa McDonough and Theresa Overholser
ISBN 978-0-7385-9976-2

Published by Arcadia Publishing
Charleston, South Carolina

Printed in the United States of America

Library of Congress Control Number: 2012954440

For all general information, please contact Arcadia Publishing:
Telephone 843-853-2070
Fax 843-853-0044
E-mail sales@arcadiapublishing.com
For customer service and orders:
Toll-Free 1-888-313-2665

Visit us on the Internet at www.arcadiapublishing.com

*To the residents of Granville, who actively maintain
the historical integrity of this beautiful town*

CONTENTS

ACKNOWLEDGMENTS

A great amount of thanks and appreciation goes out to the Granville Historical Society (GHS), one of the most modern and accessible historical societies I have ever worked with. Without its extensive archives and the help of its knowledgeable staff, this book would never have been written. GHS volunteers Janet Procida and Flo Hoffman were invaluable to this project, and sincere gratitude goes out to them. More information about the GHS and its services can be found at www.granvillehistory.org.

INTRODUCTION

Granville, Ohio, is located about 45 minutes northeast of Columbus. As recently as five years ago, the only way to enter the town from any direction was to travel several miles on two-lane roads. These small roads are now disappearing. Urban sprawl is encroaching upon Granville's quiet, picturesque existence as residents of the more commercialized urban and suburban areas of Columbus discover the quiet, old-fashioned feeling of the town.

In 2008, the number of people living in the Village of Granville was 5,382. There were 5,101 village residents in 2005. A total of 4,203 people resided in houses and subdivisions outside the village in 2008. This sector, known as Granville Township, only had 3,848 residents in the year 2000. The structures lining village streets have changed very little since they were built. A 1980 nomination resulted in 118 Granville Village properties being officially listed in the National Register of Historic Places. This is a respectable number of inclusions for such a small town.

According to Henry Bushnell, author of the book *The History of Granville: Licking County, Ohio*, a group of adventurous settlers from Granville, Massachusetts, and Granby, Connecticut, established Granville, Ohio, in 1805. Prominent families of Granville's founding community included the Bancroft family, the Case family, the Gilmans, the Roses, the Munsons, the Sinnett family, and the Spellmans. The homes that several of these highly regarded citizens built still stand today, relatively untouched by time.

The Village of Granville is worth preserving. Its collection of 19th- and early-20th-century architectural examples makes the area a destination for students and those who appreciate historic design. Pure examples of Greek Revival, Italianate, Georgian Revival, Gothic, Craftsman, Queen Anne, and Federal styles, ranging in taste from common to grand, abound. There are few, if any, homes in the village that cannot be designated as historic. It would be hard to identify the year in which a photograph of a Granville street was taken if not for the automobiles parked along its curbs.

Granville's historic downtown area is situated along East Broadway and functions as a theater for village life. Community events take place in front of the storefront buildings that house the majority of downtown Granville's businesses. In the past, grocers and hardware stores operated out of the downtown area. Restaurants and specialty shops have now replaced those vendors.

One of the earliest commercial structures in Granville was the sandstone block building that now houses the Granville Historical Society. Built in 1816, the building originally housed Granville's first bank. The building's location at 113 East Broadway Avenue is close to the Main Street intersection, which made it convenient during the time that it served as an interurban stop, from 1889 to 1923. Other early commercial endeavors in Granville included Charles Sawyer's Saddler's Shop, Joshua Stark and George Case's Brickyard, Simeon Reed's Butcher Shop, a sawmill, a quarry, several distilleries, and the Granville furnace.

As businesses in Granville began to thrive, more settlers arrived, more homes were built, and institutions were established. In 1831, The Granville Literary and Theological Institution was

founded as a secondary school for young men. In 1845, the institution became known as Granville College. In 1856, the name of the college was changed to Denison, in honor of William S. Denison, a "key benefactor" of the school. Today, Denison University is known throughout the world as a leading liberal arts college.

An early map of Granville reveals that the names of the cross streets were Pearl Street, Green Street, Liberty Street, Prospect Street, Main Street, Mulberry Street, Rose Street, Case Street, and Cherry Street. Pearl and Green streets made up one thoroughfare. Pearl was the name given to that portion of the road to the south of The Broadway, and Green designated its northern half. This pattern was repeated with Liberty and Prospect Streets, Mulberry and Rose Streets, and Case and Cherry Streets.

Main Street was the only thoroughfare that kept the same name for its northern and southern segments. The names of the highways parallel to The Broadway were The Bowery, Water Street, Equality Street, Fair Street, Solemn Street, and Maple Street. Farther north, outside of the main grid, were Market Street and Spellman Street. As with the cross streets, the names of the east- and west-running highways changed once they reached the center of town. Solemn Street, Equality Street, and The Bowery were located on the east side of town, and Maple Street, Fair Street, and Water Street were to the west.

The names of some streets have changed. In 1888, Solemn Street became East Maple Street; Equality and Fair Streets merged to become East and West Elm Street; The Bowery and Water Street became East and West College Street; Liberty Street became South Prospect Street; Rose Street became North Mulberry; Case Street became South Cherry Street; Stone and Evening Streets merged into North and South Plum Street; Market Street was renamed Summit Street; and The Broadway became known simply as Broadway.

According to William T. Utter, a former professor of history for Denison University, the establishment of water lines in 1886 made indoor plumbing possible, and in 1915, a sewer system was finally established. In his book *Granville: The Story of an Ohio Village*, Utter also recounts that houses began to be wired for electricity in the early 1920s, and Broadway became the first road in Granville to be paved, in 1916, when a base of concrete was poured and covered with a topcoat of asphalt to form a new surface. By 1917, "Main, Cherry, Pearl, Prospect, and Mulberry" had also been paved. Granville grew and adapted technologically at a slower pace than the nearby city of Newark, but it eventually acquired all of the accoutrements that were necessary to operate a modern village.

Although increased traffic from the township can cause congestion, on most days, walking the streets of Granville is like visiting an earlier time in America's history. Neighbors spend a lot of time talking with one another, and residents still gather for celebrations in the original town square. Today's suburban society accepts too readily an atmosphere of chain stores and a built environment that celebrates uniformity. Granville offers visitors a break from the monotony that is often found in other towns. The residents of Granville are passionate about preserving their history and architecture. They are proud of their quaint lifestyle and realize that they are living in one of the most perfectly preserved small towns in America.

One

PEOPLE IN
THE NEIGHBORHOOD

Born in 1859, Alice Hall Sinnett is approximately three years old in this photograph, taken sometime in 1862. Alice was the daughter of Dr. Edwin Sinnett, MD, and Sarah A. Wright. Dr. Sinnett, owner of the spectacular stone mansion at 537 Mount Parnassus, co-owned the Granville Water Cure, where patients received the benefits of hydrotherapy, and he was the president of the Bank of Granville. An undoubtedly successful man, Dr. Sinnett served as the mayor of Granville and represented the local district in the US Senate. He was not immune to tragedy, though; little Alice died in 1866, at the tender age of seven.

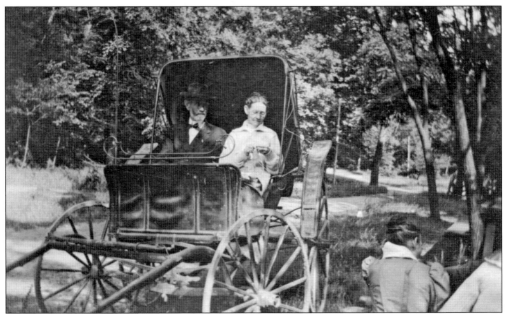

In this photograph from the late 1890s, John and Emma Robinson sit in a carriage outside of their home. Mr. Robinson was an investor and businessman who once owned the commercial building at 134 East Broadway, where the Village Coffee House is today. The couple were the parents of Hubert Robinson, a plumber and well-known citizen whose home at 121 South Main Street eventually became the Granville Lifestyle Museum. Emma was said to have always been doing needlework, as reflected in this photograph.

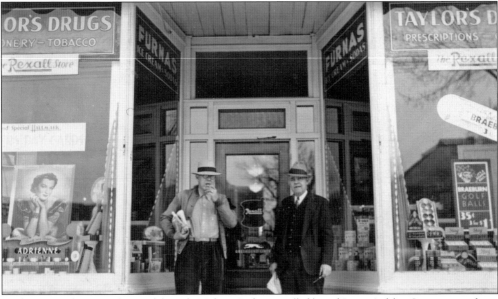

In this 1939 photograph, good friends Hubert Robinson (left) and Jerry Ackley Sr. pause in front of the Taylor Drug location in the commercial block on the north side of Broadway. Robinson, a plumber by trade, was also the assistant superintendent of the Granville Water Works at the turn of the 20th century. Ackley was a successful pharmacist who owned the Eddy-Ackley Drug Company in Newark. He, too, was involved with the waterworks as a trustee, as early as 1894.

Frank Robinson was a man-about-town in the late 19th and early 20th centuries. He was the son of John and Emma Robinson and the older brother of Hubert, one of the subjects of the defunct Granville Lifestyle Museum. Frank, a frequent traveler, worked as a clerk at S.E. Morrow's dry goods store in 1911. He died in 1946. In this professional photograph from the 1890s, Frank (second from left) poses with some friends.

Lorinda Munson Bryant is third from the right in this 1890s photograph. She was a multifaceted woman who graduated from the Granville Female Academy in 1874 and married Charles W. Bryant, the town druggist, in 1875. When Mr. Bryant died, Lorinda took over the drugstore and studied to become a registered pharmacist. In the 1890s, she left Granville and took a job as head of the science department at Ogontz College in Philadelphia. She also wrote books on art and painting, including books for children. Her most popular book, *A History of Painting*, was published in 1906.

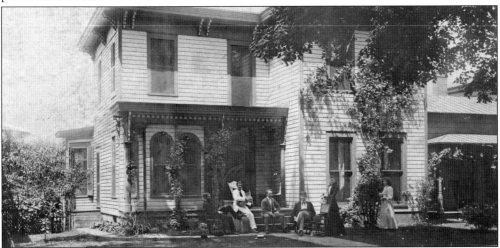

Rev. David J. Smith was a preacher in Granville in the late 19th century. His house, located at 234 East Broadway, still stands today. Reverend Smith moved into the house in 1892, and added a new porch onto the structure in 1914. In later years, the Watsons owned the home. In this photograph from the late 1890s, Rev. Smith (far left) relaxes with a few friends and family members. Charlie White, the "Philosopher of Mount Parnassus," is sitting to the right of Reverend Smith. He is wearing a white suit.

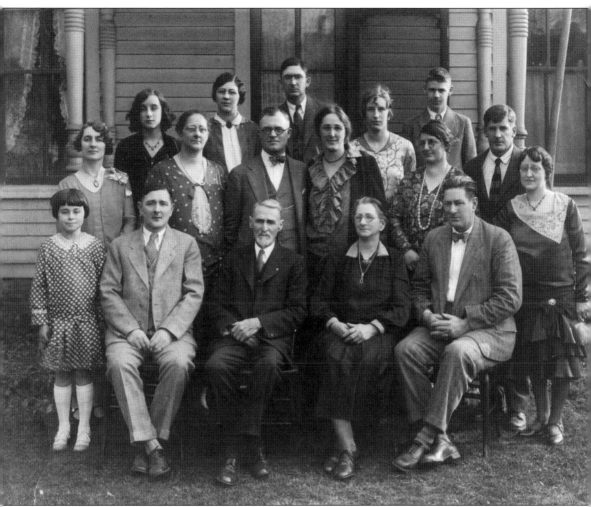

Albert Norris (1842–1936) was Granville's oldest-living Civil War veteran. He survived the war and the sinking of the SS *Sultana*, one of the greatest maritime disasters in US history. The *Sultana* was a Mississippi paddle-wheel steamboat that exploded and sank in 1865 while transporting Union soldiers home from Confederate prison camps. Of the 2,400 passengers, only 1,600, including Norris, survived. In this 1920s photograph, Norris (first row, third from left) is surrounded by his family.

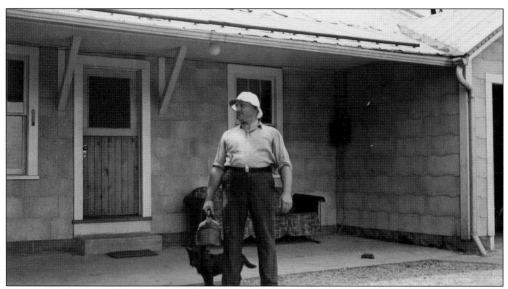

In this 1933 photograph, Granville veterinarian Owen E. Thomas stands outside of his home/office at 203 Newark Granville Road. The house was located on property next to the Church of St. Edward the Confessor. The land was purchased by the church, and Owens's house was demolished when St. Edward's Church expanded.

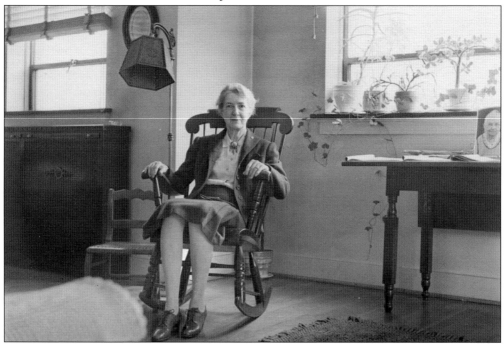

Blanche Horton was a bit of a local celebrity. In the early 20th century, most Granville residents spoke to Blanche on a daily basis, as she was an employee of the Newark Telephone Company and the telephone operator for Granville. Her first office was located in a building that stood where the CVS parking lot is now. Her second and final office was at 137 East Broadway, in the building to the west of the current Village Offices. In this 1930s photograph, Blanche takes a break from work to relax in her rocking chair.

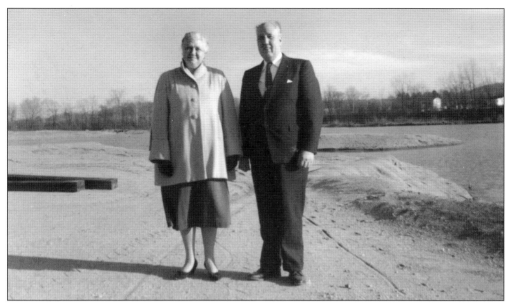

Luther Hudson "Hud" Williams was a prominent business and political figure around Granville from the 1930s to the 1960s. He owned Hud Chevrolet and served as a village councilman for several years. In this 1959 photograph, Hud and his wife, Catherine Haynes Williams, pose on the property that was to become another business venture, Lake Hudson. (Courtesy of Susie Hartfield.)

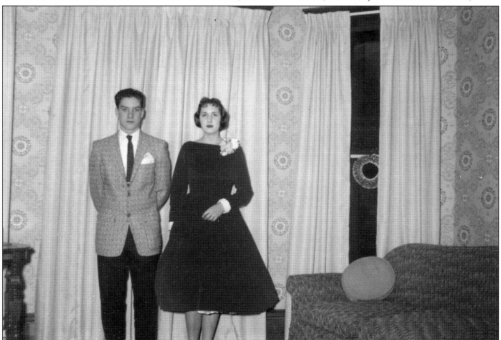

Hud and Catherine Williams had two children, Susie and Bernie. Susie went on to marry Neal Hartfield, and they had five children. Their youngest, Melissa, is the current mayor of Granville. Susie now owns and operates Lake Hudson, and Neal is an award-winning electrical contractor and the owner of Mid Ohio Mechanical. This 1958 photograph shows Susie and Neal dressed up for the Christmas holiday. (Courtesy of Susie Hartfield.)

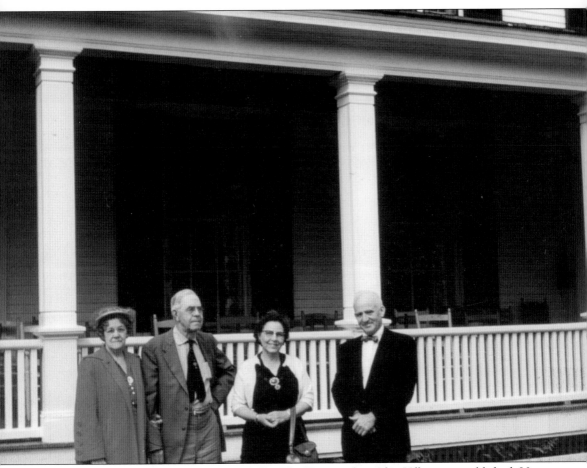

In 1956, William T. Utter's book *Granville: The History of an Ohio Village* was published. Utter was a professor of history at Denison University, and his book has been well read throughout the years. In order to gather information for the book, Utter, his wife Alma, and their friends Hubert and Oese Robinson, took a trip to New England. In this photograph, taken during that trip, the Robinsons are on the left and the Utters are on the right.

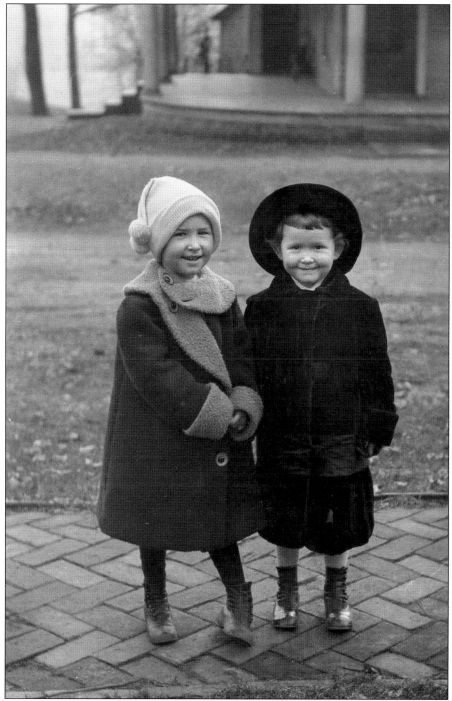

These adorable little girls are standing on the corner of South Pearl and Mulberry Streets at the turn of the 20th century. The Porch House at 241 East Maple can be seen behind them. During this time, children were treated as little adults who were expected to go to work to help out their families as soon as they were able. Childhood did not last long, but judging by the smiles on these girls' faces, they are still in the prime of theirs.

This unidentified little girl is standing on the front steps at 236 South Pearl Street. She is about three years old in this photograph from the turn of the 20th century. During this time, children wore clothing and donned accessories similar to those of adults, only smaller. Our little model has on a pair of boots that are a lot like the ones her mother would have worn. The adult version would have had a pointed toe and a heel but would have been made out of the same kid leather as the pair seen here.

Two

A Day in the Life

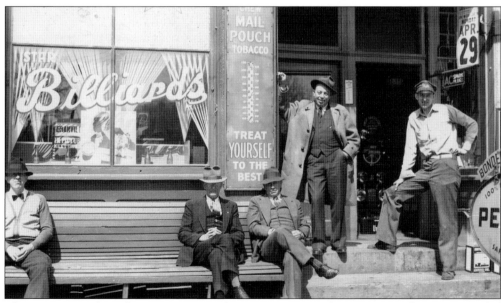

There were a number of businesses on North Prospect Street in historic Granville. Some provided townsfolk with the supplies they needed to run their households. Others, like Star Billiards, provided them with a place to relax after a long day. This 1930 photograph shows a group of suited men and a uniformed Pennzoil employee enjoying a break outside of 128 North Prospect.

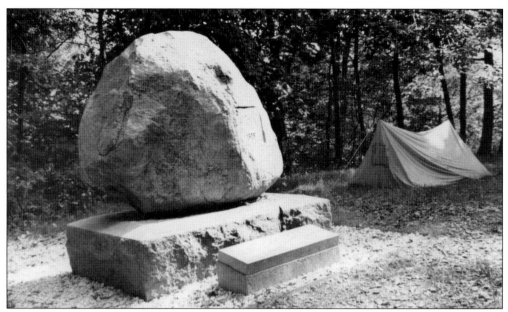

In 1905, trees were planted to reforest Sugar Loaf, and a glacial boulder from the west side of town was installed on top of the hill as a monument to early Granville settlers. By the 1960s, Sugar Loaf was full of mature trees. In 1969, the village took over maintenance of Sugar Loaf, declaring it a protected area to prevent development and preserve it as a public park. Throughout the years, many Denison students and village residents have discovered camping on Sugar Loaf. In this 1970s photograph, a tent has been pitched next to Boulder Monument.

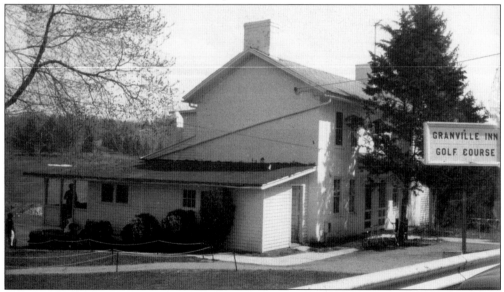

The Golf House served as the place for golfers to pick up supplies for their outing, take social breaks from playing, and visit the locker room. It was also the home of the course's manager and his family. The first managers of the Granville Golf Course were the Murrays. Alex Murray, his wife, and their kids lived in the apartment on the top floor of the house. In this 1950s photograph, the sign in front of the house reads "Granville Inn Golf Course," indicating that the golf course and the inn were associated.

20

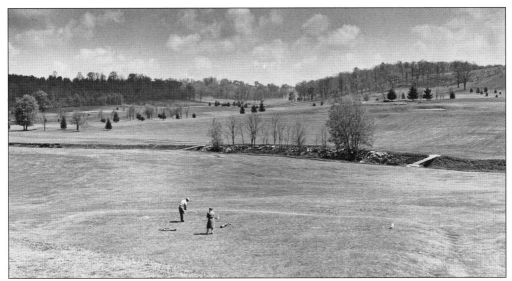

Donald Ross, a world-famous golf course architect of Scottish descent, designed the Granville Golf Course. Local coal and railroad magnate J.S. Jones included the course as part of his Granville Inn complex. There was a Granville Golf Club made up of doctors, lawyers, dentists, and other local businessmen who played a round every week. Here, two unidentified golfers test their skills on the green.

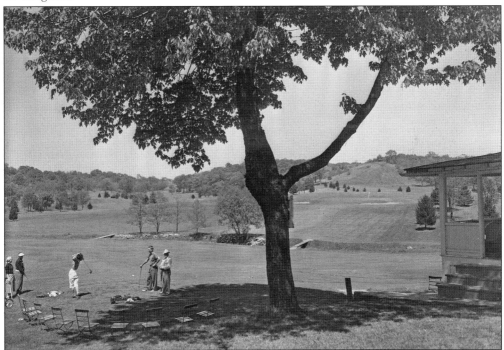

In the early days of the Granville Golf Course, there were no tees. Golf balls were set on a mound of special sand. Caddies, some as young as seven years old, waited on players from the area and from other towns, including Cleveland, Pittsburgh, and Detroit. In the late 1920s, caddies made from 65¢ to $1.00 for accompanying players up to 18 holes. Here, a group of unidentified men and women navigate the course without the help of a caddy.

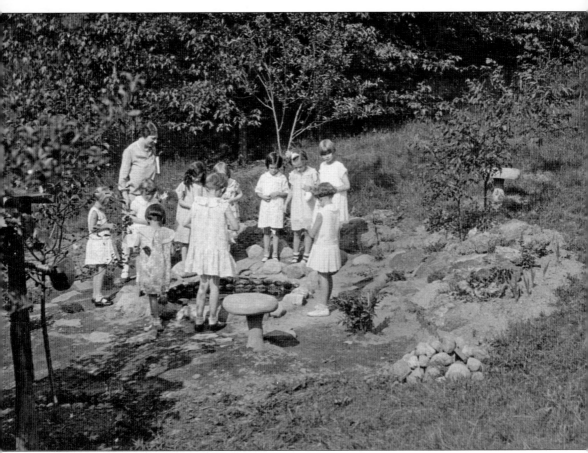

Pruney Jordan was an alumnus of the Granville High School football program and became a scout, or "dopester," for the team in 1925. He made local news in 1927, when he saved his soda fountain from a fire. Jordan hosted a birthday party for his daughter at his home at 415 East Broadway. At the party, held in the mid-1920s, the little girls and their teacher, Helen Goodell, gather around a beautifully landscaped pond on the property.

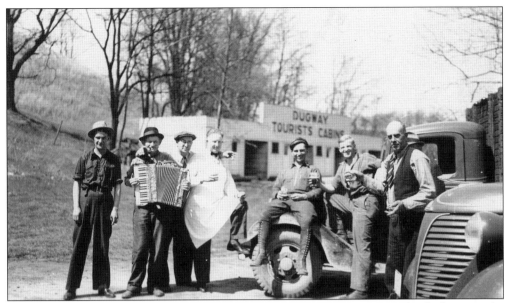

The area at the end of Newark-Granville Road, where it meets Route 16, used to be home to the Dugway Tourist Camp. Complete with cabins and wash areas, the Dugway was a stop for many travelers. Some of the visitors to this area were of the criminal persuasion. Highway robbers hid in the Dugway in 1898 and 1903. A high-speed accident there in 1928 ended in a fire. In this 1939 photograph, a group of travelers spend a little leisure time at the camp.

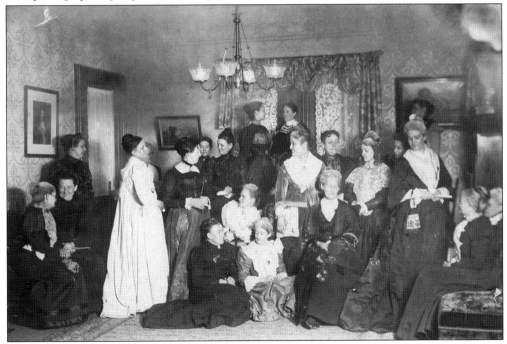

The Fortnightly Club, also known as the Fortnightly Travel Club, was a women's group that met regularly to discuss topics of travel and entertainment. The club hosted debates, lectures, and events as part of their activities. At this meeting in the late 1800s, members of the Fortnightly Club celebrate Colonial times at a themed event.

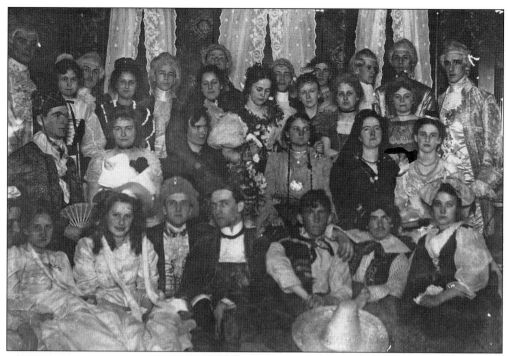

Celebrating the birthday of George Washington was a popular activity in historic Granville. Denison University hosted a yearly banquet in Washington's honor, and private parties dedicated to the nation's first president gave residents a reason to dress up and socialize. On February 22, 1892, a group of young partygoers in period costumes attended a Washington-themed event.

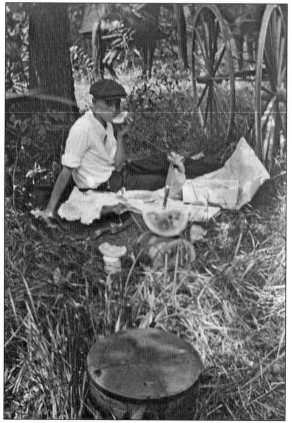

A lot can be said about Richard "Dick" Howe. He graduated from Granville High School in 1916, worked as a wireless telegraph instrument operator until 1917, and broadcast from the Denison University radio station in 1926. Howe also produced the Exhibit of Electrical Phenomena for the Newark Electrical Show in 1936. Later in life, he was the president of the Granville Historical Society. Here, a young Howe takes a leisurely lunch break in the early 1900s.

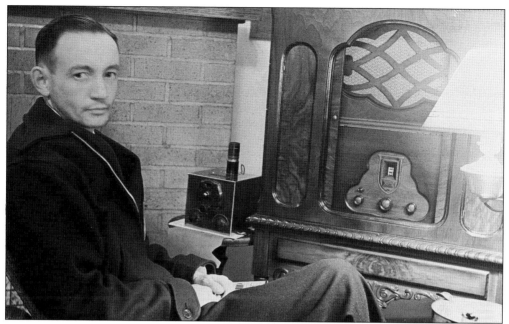

Dick Howe, known primarily as a physics professor at Denison University, was also an avid "techie," deeply interested in electricity and gadgets. In 1936, he gave a lecture on electricity to 400 residents of the rural areas outside of Granville. In 1940, he experimented with radio frequency modulation. Howe, mechanically inclined, liked to toy around with airplanes from time to time as well. In this photograph from the early 1930s, Howe is sitting in front of an early radio set.

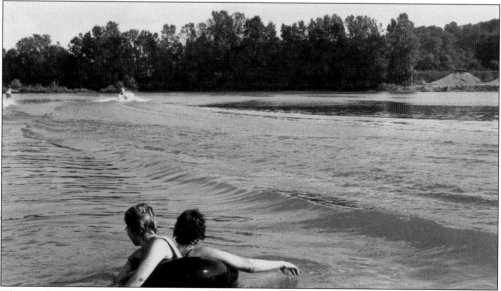

The predominant place for swimming from the mid-1930s to the late 1950s was Spring Valley Pool. That all changed on Memorial Day weekend in 1958, when Lake Hudson opened. A gravel pit that once belonged to Hammond Sand and Gravel was filled with water, forming the lake. Lake Hudson has provided Granville residents with a place to cool off in the summer for over 50 years. Here, a couple of swimmers enjoy the water in the lake's first year of existence. (Courtesy of Susie Hartfield.)

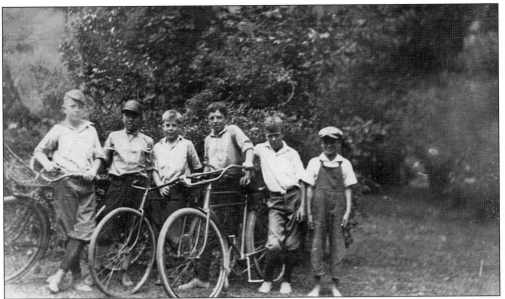

In the 1920s, young boys could participate in many leisure activities. In the warmer months, they played football, baseball, and basketball. They went swimming and played around by Raccoon Creek. Every once in a while, boys got into trouble. In 1925, a group of youngsters was reprimanded for throwing snowballs at people walking to a church social. In 1926, the village had a problem keeping them off the Town Hall (opera house) fire escape. The local boys in this 1920s photograph look mischievous enough to have participated in both of those activities. (Courtesy of the Montgomery family.)

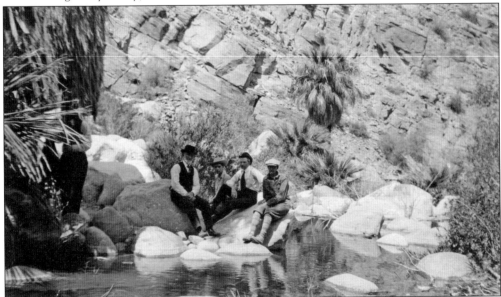

Among the many trips taken by Frank Robinson was an Easter holiday in California in 1925. Accompanying him was his uncle, Sam Devenney (far left), who owned a successful farm on Loudon Street. Reported to be a "livestock pioneer," he was 79 years old when this photograph was taken. In 1897, Devenney incurred a serious injury when he was kicked by one of his animals. A local philanthropist and a 54-year member of the Masons, he died in 1933.

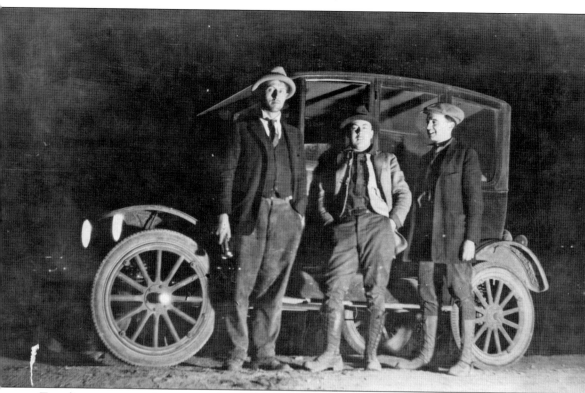

Traveling was a popular pastime for wealthy Granville residents. Some, like Frank Robinson, took trips every year. In this photograph, taken by Robinson on March 19, 1925, Walter Brown and two unidentified friends pose by the car they had employed to drive them across the country. The car, a Flivver coupe, was affectionately named Betsy by the group and was mentioned often in Robinson's and Brown's diaries.

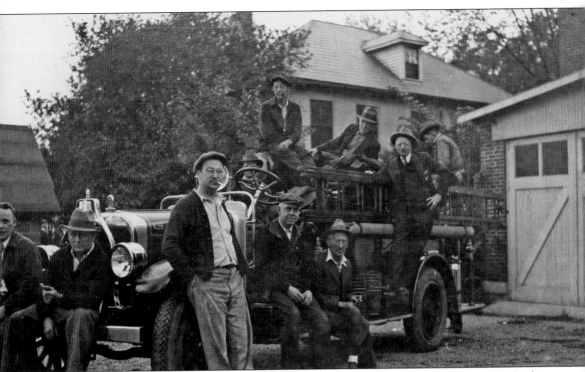

A group of volunteer firemen pose with Granville's only fire truck in 1933. At that time, the fire department operated out of the Village Hall on South Main Street. The department received its own building on North Prospect Street in 1937 and is located there to this day. This photograph, taken in a parking lot behind the Village Hall, includes Dave James, George Thompson, Abe Price, Allen Wright, Pelo Weston, Hubert Robinson, Shide Evans, Billy Thomas, Tim Miley, and "Plink" Rogers.

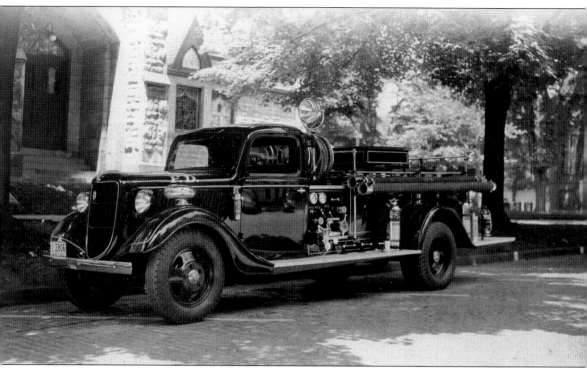

In 1927, following the fire that destroyed the south side of Broadway's business district, Granville got its first fire truck. The vehicle, built by the Peter Pirsch Manufacturing Company, was equipped with a chemical tank and 700 feet of hose. In 1937, another truck, shown here that same year, was purchased. Built by the Hanley Company for just over $3,000, this 110-horsepower truck could pump 700 gallons of water per minute.

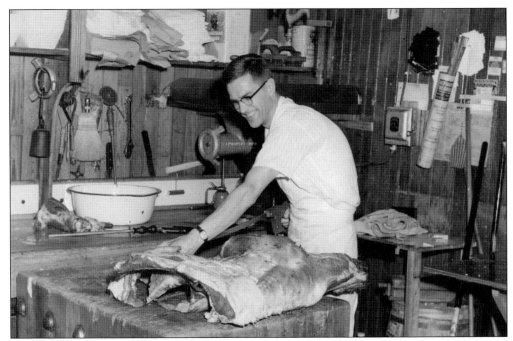

Harold "Buck" Sargent was a popular resident of Granville. He was a member of the Granville Historical Society, Granville Business and Professional Association, and the Granville Rotary Club. Sargent was on the Village Council, worked for the Village Planning and Zoning Commission, and served as a volunteer fireman. He was the director of the Robbins Hunter Museum, a trustee of the Licking County Historical Society, and was involved with the Webb House Museum in Newark. He was also Granville's butcher. In this photograph from the 1950s, Sargent cuts a slab of meat for a patron. (Courtesy of the Sargent family.)

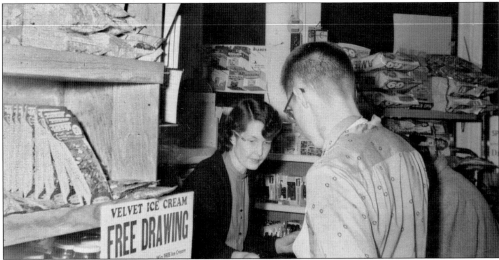

Sargent's Market was located at 126 East Broadway, where the Broadway Pub is today. Owned and operated by Harold "Buck" Sargent and his wife, Flora, the market served fresh-cut meat. Previous Granville butchers included J.B. Pierson, Dick Case, and Chester Woolard. Sargent retired from butchering in the 1980s and passed the business on to the Blackstone family. The shop was finally closed in 2003. In this photograph from 1954, Dora rings up a patron.

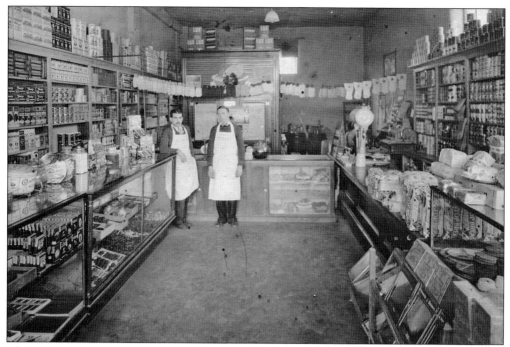

The interior of a grocery store is seen here in 1920. Only dry goods are available, as produce and meat were purchased at other establishments. Standing inside this store, called the Huffman Market, are John Huffman (left) and Paul Tatham. Huffman Market was located in the commercial block along North Prospect until 1939, when it was replaced by a poolroom. Other grocers in Granville's history include McCollum's and Fuller's. Paul Tatham also worked for Fuller's Market and retired from the grocery business in 1940.

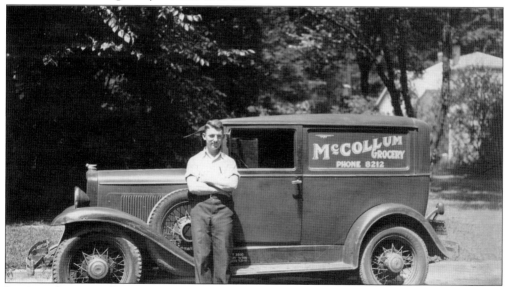

In 1910, the *Granville Times* reported that a new grocery was to be located in the rear of the Opera House. McCollum's Grocery was the name of that store. I.G. Fuller turned it into Fuller's Grocery in 1937. Here, employee Ralph Hood poses with the company vehicle in 1936. Hood began working for McCollum in 1932 and left in 1936 to work for Kroger.

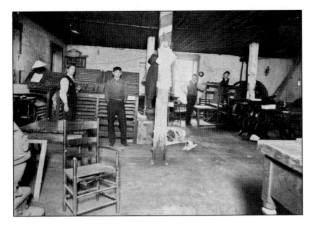

The *Granville Times* newspaper was founded in 1880. Over the years, it had several owners, including W.C. Sprague, F.W. Shepardson, and W.H. Kausmaul. In this photograph, taken in the early 20th century during the Kausmaul years, Jud Evans (far left) and Lou Kausmaul (second from left) pause from their work in the *Times* print shop. Evans began his career with the paper in 1891, and Lou Kausmaul eventually became the foreman of the newspaper's main office.

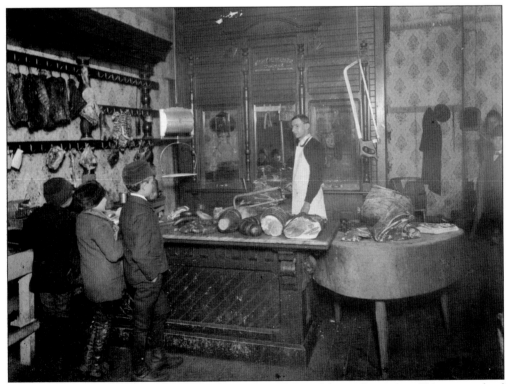

Chester Woolard worked as a butcher in the early decades of the 20th century. He was involved with several meat market companies until he could finally purchase his own. After partnering with Charles Heil to acquire the Fred Siegle Meat Market in 1932, Woolard moved into the former Piper Meat Market location at 204 East Broadway. Shown here in the early 20th century, Woolard cuts a slab of meat as an audience of children looks on.

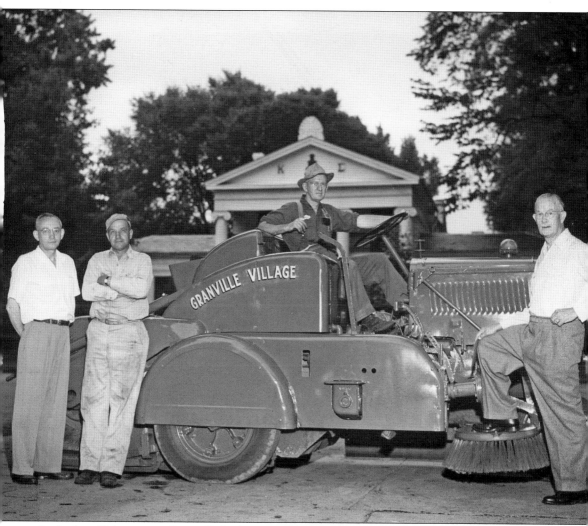

In the late 19th century, Granville had a group known as the Street Cleaning Brigade that kept the thoroughfares passable. By the time this photograph was taken in the 1950s, the village had a machine to maintain the streets. Posing with this heavy piece of equipment are Dick Howe (left), Paul Ramsay (on machine), and John Bjelke (far right). The man next to Howe is unidentified. Howe was a physics professor at Denison University and a wireless telegraph instrument operator. Bjelke was chairman of the local draft board in 1940.

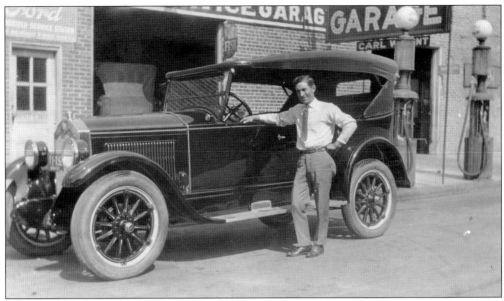

The Granville Service Garage, owned and operated by Carl Weiant Sr., was located at 121 North Prospect Street. Weiant, also the proprietor of a local bus line, began building his career in the transportation industry in 1915. The Granville Service Garage was authorized to service Ford cars. In 1937, a new owner took over the business. In this 1930s photograph, Weiant stands outside the garage next to one of the many vehicles his shop maintained.

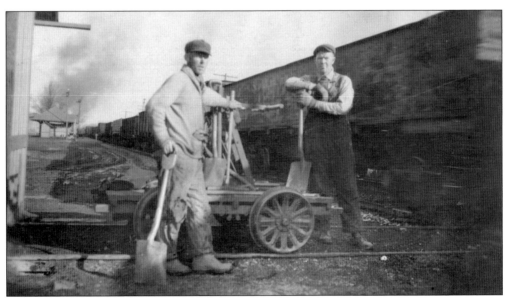

The train station depot at 124 South Main Street served the public for decades as a stop on the Toledo & Ohio Central Railroad. The Ohio Central Railroad built the station in 1880. In 1885, Ohio Central became Toledo & Ohio Central, and the depot became part of that line. The back of the depot can be seen in the top left corner of this photograph, taken in the 1930s. In the foreground, two rail workers pause as a train moves slowly past.

The entrance to the Maple Grove Cemetery is hidden at the eastern end of Maple Street. The cemetery was established in July 1864 because the Old Colony Burial Ground had reached capacity. Many families moved the bodies of their loved ones from other cemeteries and had them reburied at Maple Grove when plots became available. Before the advent of bulldozers, men were employed as gravediggers to hollow out an interment spot. Here, two workers at Maple Grove take a break from shoveling in the 1920s.

Denison's Barney Davis Hall, built in 1894, honors railroad car manufacturer Eliam Barney and Samuel S. Davis, a benefactor of the hall's 1996 renovation. Another 1996 benefactor, Walter McPhail, was honored with the McPhail Center for Environmental Studies, located inside Barney Hall. In 1905, the original building was all but destroyed in a fire. This 1906 photograph shows a group of workers whose efforts led to the rebuilding and fireproofing of Barney Hall after the blaze.

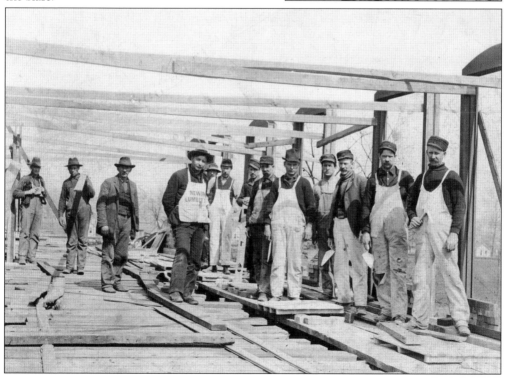

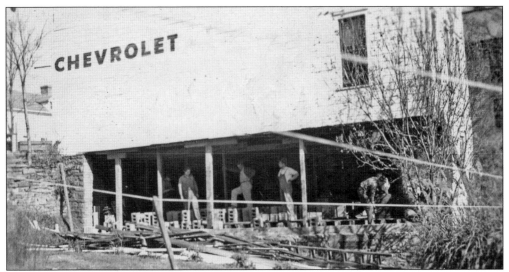

Hud Chevrolet was a successful car dealership located at 1115 East Elm Street. From 1937 to 1950, cars were on display in the building that now houses Subway. The need for a larger showroom became apparent as the business grew, and an addition was erected. Here, crews are busy constructing the building that would serve as the Hud Chevrolet showroom until 1961. The addition was turned into Elm's Pizza when the dealership closed. The restaurant, run by Bernie Williams, son of Hud, remains in business today. (Courtesy of Susie Hartfield.)

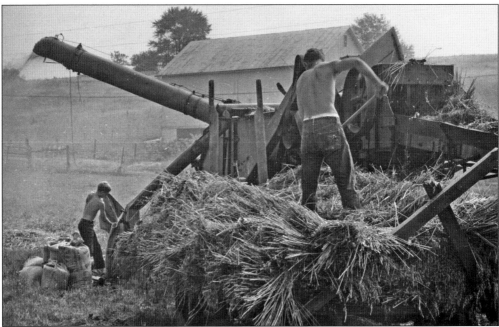

Threshing machines were part of the yearly crop harvest for Granville farmers. A crew of men would use pitchforks to heave crops into the machine, which would separate grain from the stalks and husks. The thresher took care of the most time-consuming part of the harvest, but operating and loading the machine was hard work. Farmers who were affluent enough to afford a thresher often loaned it, and themselves, to other farms. In this 1950s photograph, a threshing machine owned by the Hankinson and Philipps families is put to use. (Courtesy of the Philipps family.)

Cora "Bird" Griffing poses with her class of elementary students from the Granville School in the late 19th century. Ms. Griffing, who received her teaching certificate in 1896, was an instructor at schools in nearby Liberty Township (1890) and Johnstown (1891). She was listed as an officer of the Spring Valley Lodge in 1899. In 1900, Griffing married Bert Everett and stopped teaching.

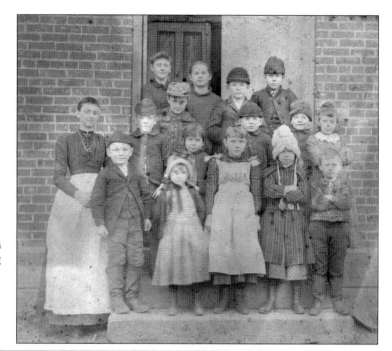

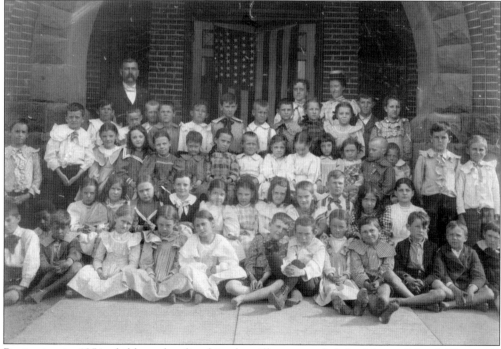

Beginning in 1854, children that lived in the village attended the Union School. This early building was located on the site of the current Granville Elementary School. Kids living outside of the village attended schools that were located in various sections of the township. In 1888, the original Union School was torn down and a new institution, Union School, was erected in its place. In this photograph, taken in the early 1890s, a class of young learners sits outside of the recently constructed Union building.

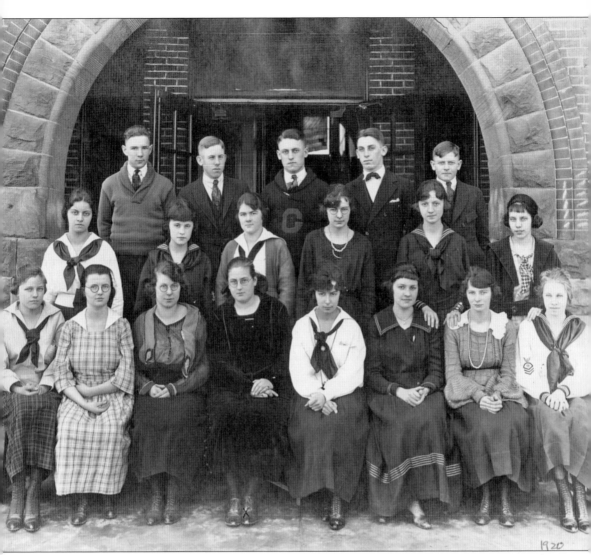

1920

In the late 19th and early 20th centuries, children of all ages attended the same school. Each grade had a small number of students, and the teachers were generally female. Early teachers at Union School, Granville's public learning institution in the 1890s, included Ida Eno, Lucy Sanford, and Anna Spellman. When the class of 1896 graduated, spectators were charged 10¢ to 15¢ to attend the ceremony. This photograph features the entire Granville, Ohio, graduating class of 1921, posing on the front steps of Union.

A school bus makes its way to the village from one of the outlying township neighborhoods. At the turn of the 20th century, children living outside the village attended school in small country buildings located in their immediate areas. Former country schools included Deeds School to the south and Welsh Hills School to the east. Eventually, those institutions were closed, and township children were bussed into the village to attend classes at Union School on Granger Street.

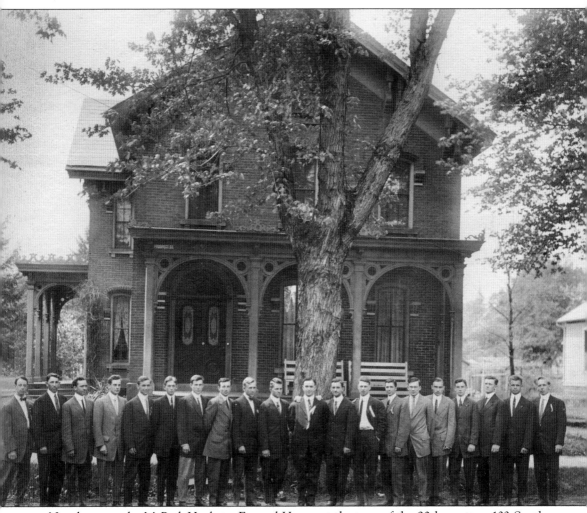

Now home to the McPeek-Hoekstra Funeral Home, at the turn of the 20th century, 133 South Prospect Street housed members of the Sigma Chi fraternity. In those days, there were no fraternity houses on the Denison University campus. As a result, chapters operated out of various houses in the village. The Sigma Chi members later inhabited the College Town House on East Broadway. The fraternity is seen here posing in front of the McPeek-Hoekstra building in the late 1800s.

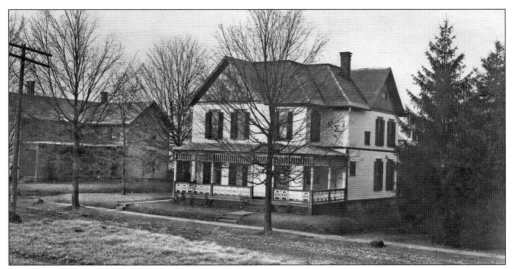

This house at 113 Shepardson Court once belonged to George R. Stibitz, an artist, mathematician, and inventor who is regarded as the father of the modern digital computer. Stibitz graduated from Denison University in 1926 and went on to work for Bell Telephone Laboratories. By the end of his lifetime, he had accumulated 38 patents and secured himself a place in computer science history. This photograph was taken in the early 20th century, when the home was being used as a fraternity house.

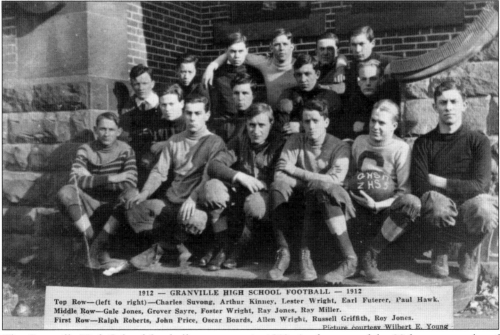

1912 — GRANVILLE HIGH SCHOOL FOOTBALL — 1912
Top Row—(left to right)—Charles Suvong, Arthur Kinney, Lester Wright, Earl Futerer, Paul Hawk.
Middle Row—Gale Jones, Grover Sayre, Foster Wright, Ray Jones, Ray Miller.
First Row—Ralph Roberts, John Price, Oscar Boards, Allen Wright, Russell Griffith, Roy Jones.
Picture courtesy Wilbert E. Young

The Granville High School football team poses in 1912. At the turn of the 20th century, a lot of football was played in Granville. In addition to the high school, Denison University had a team. In 1899, the *Granville Times* urged residents to support the sport by attending a local game. By 1925, the Opera House was showing moving pictures of GHS bouts. In the early 1900s, the high school team faced opponents from Johnstown, Worthington, and Grandview. From 1918 to 1925, they played 48 games and lost only 4.

The Reserve Officers Training Corps (ROTC) was formerly a mandatory program for young men in college, but the group fell out of favor during the antiwar sentiments of the late 1960s and early 1970s. Denison University had its own corps of ROTC members. They had an annual ball every year and even organized a summer camp to practice their maneuvers. The group also had an annual parade, held in November, in which ROTC leaders from other college campuses could participate. Here, a group of young men prepares to participate in a ROTC parade in the 1950s. (Courtesy of Ann Ormond.)

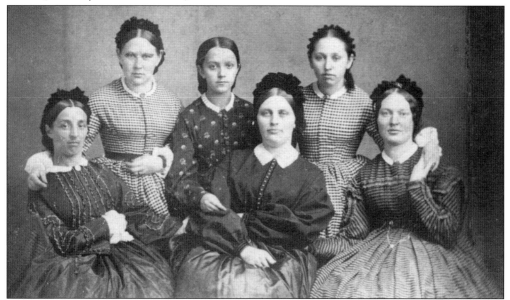

In 1834, prominent citizens of Granville, including Rev. Jacob Little and Henry Bancroft, began planning a school for the female population. Called the Granville Female Academy when it opened in 1838, the school taught young girls and women. By the time the school closed in 1898, approximately 60 groups of students had graduated. This photograph shows one half of the class of 1863.

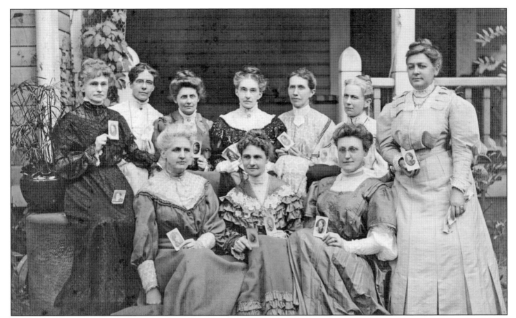

In 1862, the Granville Female Academy became Granville Female College (GFC). The building that housed this school for women was located at 314 East Broadway, the current site of the Granville Inn. In 1844, tuition for GFC was $4.50 per quarter. The curriculum changed as the school gained students. In the second half of the 19th century, it became known as a fine arts college that trained women in arts, including music and oil painting. This photograph, taken during a reunion in the 1880s, shows the GFC class of 1874.

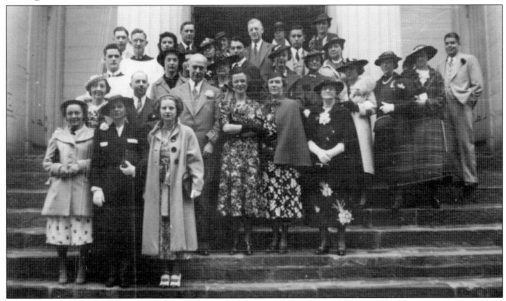

The parish of St. Luke's Episcopal Church was formed after several members of the Granville Congregational (now Presbyterian) Church were vilified for choosing to work on a Sunday. In 1827, St. Luke's parish was officially established, but the familiar Greek Revival structure at 107 East Broadway was not completed until 1837. In this 1940s photograph, a much more understanding group of patrons poses on the front steps of the church building.

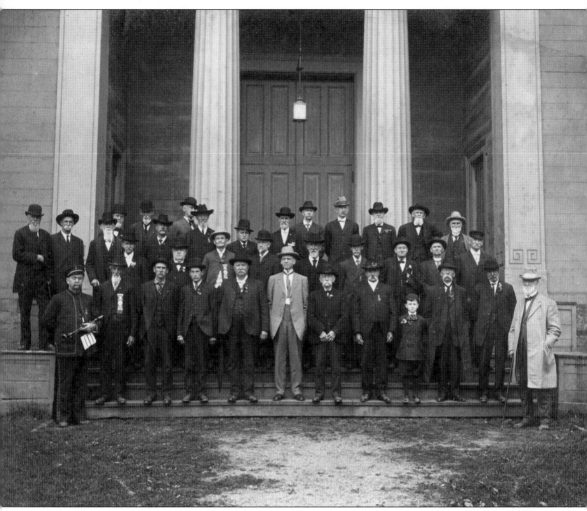

There was hardly a family in Granville that did not produce a soldier during the Civil War. Some of these soldiers achieved great honors while serving in battles such as Bull Run and Shiloh. Many who left to fulfill their military duty did not survive to return home. After the war, efforts were made to acknowledge Granville's Civil War veterans on a regular basis. In this 1910 photograph, taken on the steps of St. Luke's Episcopal Church, a group of soldiers gathers in a solemn moment.

Three

CELEBRATING GOOD TIMES

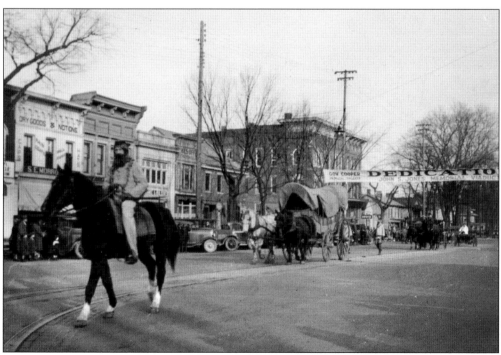

A historical pageant was part of the parade that honored J.S. Jones during the celebration of the opening of the Cherry Street Viaduct on November 27, 1929. It was reported that Frank Weston dressed as an American Indian on horseback, pulling a teepee. Mrs. George Futerer followed him, dressed as a squaw. Next came Fred Siegle and Tim Simmons in outfits befitting pioneer scouts. In the above photograph, Simmons is shown on horseback, leading the way for a covered wagon driven by Orville Fields.

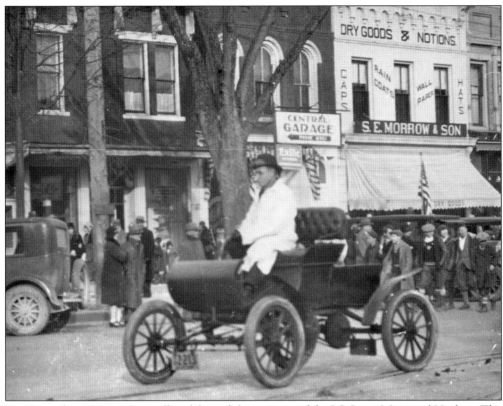

On November 27, 1929, Granville celebrated the opening of the J.S. Jones Memorial Viaduct. The viaduct is a bridge with several large spans, totaling 615 feet in length. It is located on Cherry Road and straddles Raccoon Creek. The viaduct was named after Jones, a local businessman who championed progress by way of engineering. Part of the celebration included a parade that began at the intersection of Broadway and Prospect Street. Here, B. Sigler drives an "abbreviated" chain-driven Cadillac along the parade route.

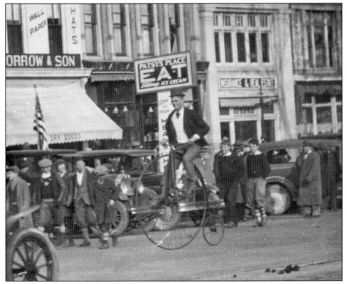

The parade that celebrated the opening of the J.S. Jones Memorial Viaduct was a big part of the day's activities. Here, local resident Abe Flory rides along the parade route on an old bicycle. After the parade, which ended at the viaduct, approximately 2,000 people enjoyed a speech by Gov. Meyers Cooper, a ribbon-cutting ceremony, and a flyover by O.W. Nichols and Herman Pheneger's plane, *Maid of the Skies*.

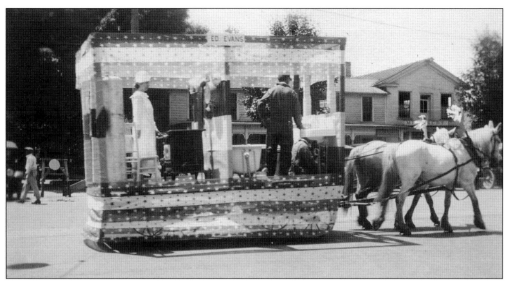

Ed Evans was a master plumber from 1916 to the early 1940s. He had an office on Broadway and worked for a plumbing and heating company called Mister Quick in the mid-1920s. Frank "Pelo" Weston took over Evans's business in 1940. Evans died in 1941. During a Fourth of July parade in the early 1920s, Evans takes advantage of the opportunity to advertise his business and show off a few of his wares.

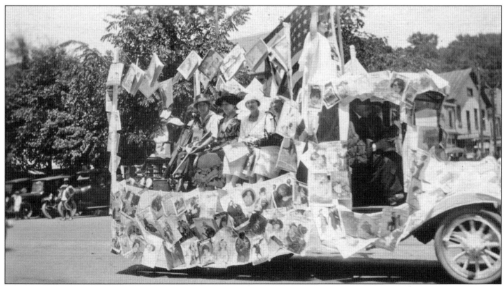

Many groups and residents competed for the honor of having the best float in Granville's annual Fourth of July parade. Elaborate floats were created by decorating cars with tissue, crepe paper, and fabric. This painstaking task took days and resulted in some of the most interesting designs. In this 1920s parade, a local women's group rides through town on a float pasted with magazine covers from various publications. All of the covers feature female subjects.

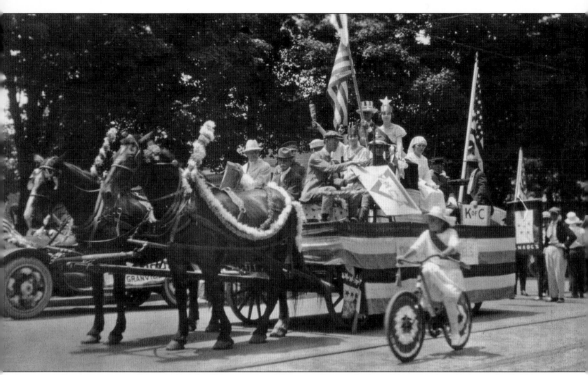

This interesting 1920s parade float, created by members of a local benevolent group, harkens to the story of Cornelia, "mother of the Grachii." Cornelia is a figure from Roman history who had 12 children. Only three of the offspring survived to adulthood, and they became political leaders. Cornelia referred to these sons as her "Jewels." This float, owned by H. Dean Ashbrook of the Granville Flour Mill and Earl Cheshire of the Granville Lumberyard, displays a banner that says, "These are my Jewels." Goldie McLain Howe, holding a torch, is portraying Cornelia.

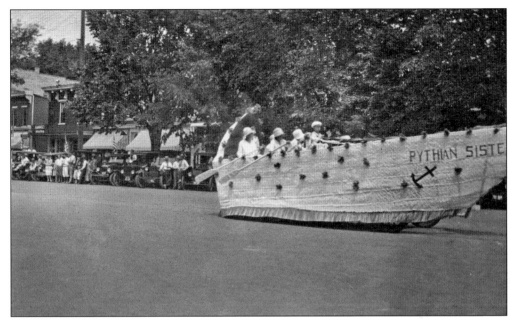

Granville began officially celebrating the Fourth of July in 1910. The Civic Improvement Society organized the first official celebration, funding it with money collected from town residents. The highlight of the first celebration was a fireworks display that featured Roman candles. Prizes were handed out for the best parade float. In this 1926 photograph, the Pythian Sisters, a fraternal organization of women, shows how the practice of decorating floats evolved into an elaborate affair.

This early 1920s Fourth of July parade features a man wearing a barrel. While it is common to this day to see a fully dressed clown wearing a barrel, this adventurous man has taken things a step further by not wearing clothing under his prop. This parade took place at the beginning of the Prohibition era, and it is possible that the barrel-wearer is making a statement about the matter.

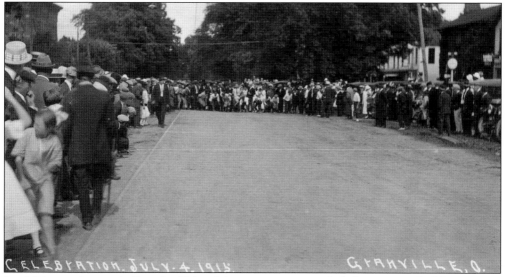

In addition to the parade, Fourth of July celebratory activities included a picnic and athletic events. Prizes for winners of events such as the 50-yard dash, sack race, wheelbarrow race, and baseball throw included a haircut from a local barber and $1.00 in cash. In 1915, competitors take their marks on Broadway at the start of a race, while an enormous crowd looks on.

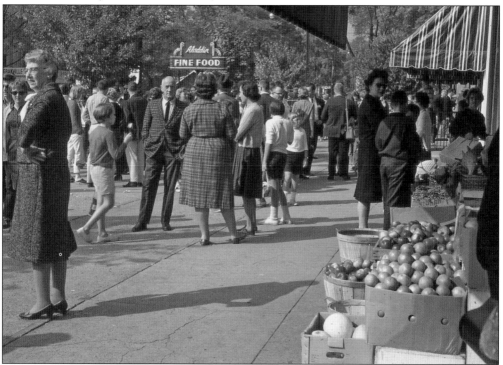

The Granville Fourth of July celebration has been a major occurrence for over 100 years. Events held on this festive day have changed, but everyone in town still finds time to participate in the party. This photograph from 1962 shows just how many people are enjoying the celebration. A very young Janet Philipps Procida, longtime Granville resident and author of *The Welsh Hills*, can be seen walking through the crowd in the left foreground.

In the early 1960s, the Granville Fourth of July celebration became a carnival. Rides were brought in from various vendors, and the town came out in force. Children especially loved the rides. When the vendors pulled into town, kids from all over would head down to Broadway to see the rides erected. This tradition has not ended. Granville still has a carnival every year, and rides are the main attraction. This 1970 photograph shows how the rides used to light up downtown.

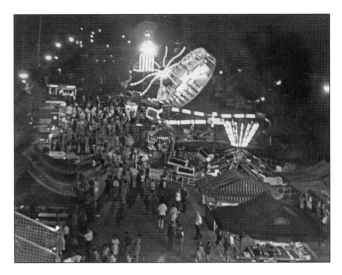

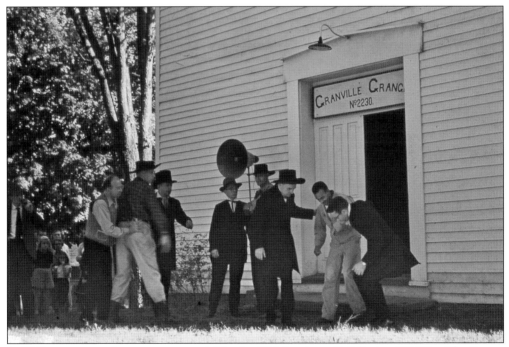

In 1841, a runaway slave was put on trial in the Old Academy Building at 105 West Elm Street. The slave escaped from the South and was hiding out in Newark. Judge Samuel Bancroft decided that it was unconstitutional to send the slave back to the South, and he was freed from custody. In this 1955 reenactment, a group witnesses the moment when the slave is freed from his shackles. The reenactment also featured a waiting horse that the slave mounted before continuing on his way farther north.

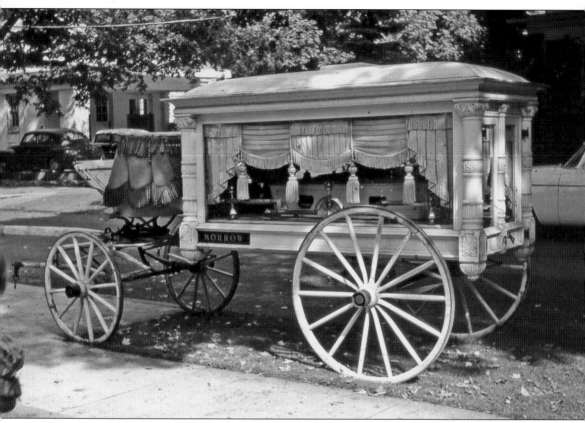

The owners of the Morrow Funeral Home parked this antique hearse on Prospect Street as part of Granville's 1955 sesquicentennial celebration. The purpose was to provide residents with a glimpse of Granville's funerary past. James K. Morrow, a mortician, purchased the house at 133 South Prospect Street from a relative in 1938. It is now owned by the McPeek-Hoekstra families and continues to serve the community as a funeral parlor.

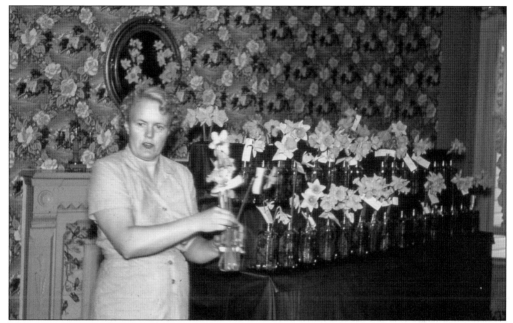

The Granville Daffodil Show is an annual event that, until recently, was held in the College Town House. Nowadays, the show, which is put on by the Granville Garden Club, is held in the Bryn Du Mansion. It has grown into a major community event featuring live music and garden art. Here, a member of the club stands by a display of daffodils in 1959. The Granville Garden Club has been in existence since 1931, and the show now features approximately 300 daffodils each year.

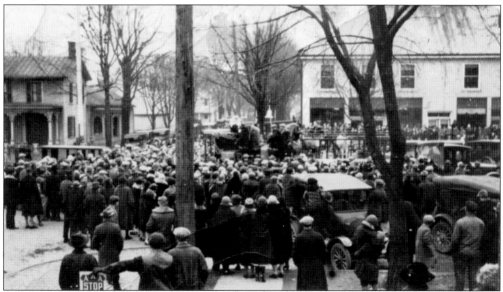

According to articles in the *Granville Times*, Santa made several visits to town. The earliest visit on record was made in 1907. Here, Santa and his sleigh turn onto Broadway from Prospect Street in 1926. Since there was no snow that day, the sleigh was mounted on top of a flatbed truck and driven through town. Families stood in the cold to get a glimpse of Santa, and children scrambled to grab the candy he threw. (Courtesy of the Williams family.)

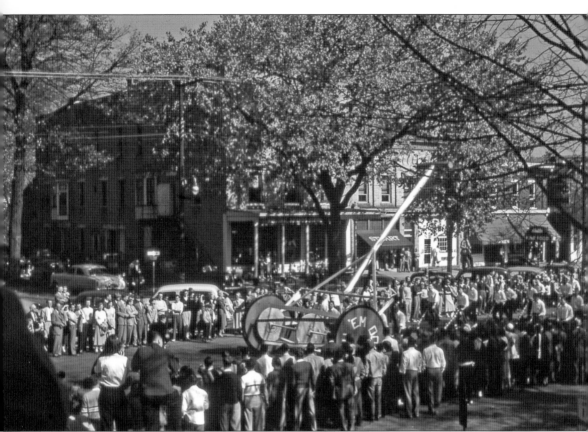

The annual Denison University homecoming parade used to be held on the streets of downtown. As with the Fourth of July celebration, residents would gather to enjoy the party. Homecoming events reflected an undertone of rivalry with another college football team, a fact that is undeniable based on this 1950 photograph. A giant lawnmower has been constructed, and it sits in the center of a crowd of onlookers, waiting to "Mow Down the Competition."

Four

Changing Faces
of Downtown

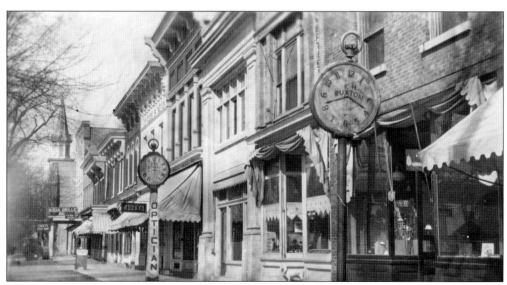

The clocks in this photograph from the turn of the 20th century never worked. They were never intended to work, because they were painted sculptures used by George Stuart and F.H. Buxton to advertise their businesses. The time on both clocks was depicted as 8:20, commonly known as "stop clock time," chosen as such because 8:20 was said to be the precise time that Abraham Lincoln died. The clocks disappeared in the 1930s when the corresponding businesses closed.

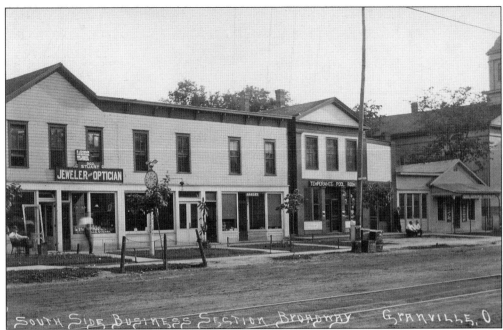

In 1963, longtime Granville resident Minnie Hite Moody described downtown as it had appeared early in the 20th century. According to her recollections, the Oaks For Meals restaurant occupied the building that now houses the Granville Historical Society. A pool hall was located to the right of Oaks For Meals, Futuro's Bakery was to the right of the pool hall, and the gas office was to the right of the bakery. This photograph, taken in 1917, shows how the south side of Broadway's business district looked not long after the period described by Moody. Oaks For Meals has become the Oak Dining Parlor, but it and the pool hall are still in use.

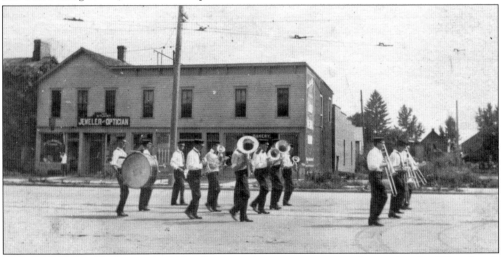

On the morning of February 1, 1927, a fire started in a restaurant on the south side of Broadway's business district. When the fire reached the restaurant's gas-heated water tanks, two large explosions occurred. The Granville Volunteer Fire Department lost control of the blaze. The damage, totaling $50,000, was the worst the town had seen up to that time. In this photograph of a parade in the late 1920s, an empty space appears where the Temperance Pool Room and its associated buildings used to be.

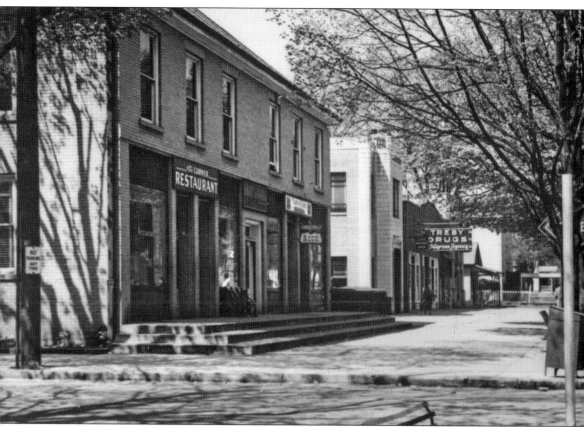

There have been many businesses in downtown Granville over the years. Some have been variously located on both the north and south side of the Broadway business district. Others have stayed in one place until they ceased operation. This 1960s photograph shows a couple of former south side tenants located on the corner of Prospect and Broadway, where the Reader's Garden is today. W.C. Treby owned Treby Drugs, and his 3 occupied the same block as the Corner Restaurant.

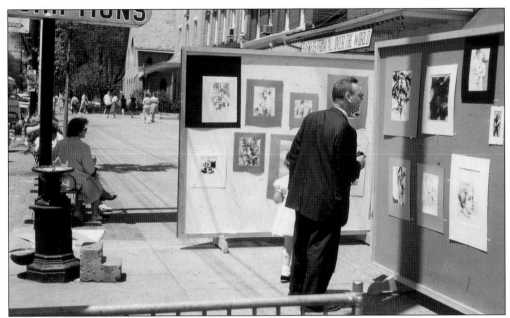

This 1961 photograph was taken at an event that was something of a precursor to the annual Granville Streetscapes festival. This art exhibit, set up in the downtown business district, drew multiple spectators. George Hunter, a former professor of music at Denison University, can be seen in the foreground of this photograph, taking a look at a display. Hunter was a gifted trumpet player and a member of the Presbyterian Church. Also of note is the water fountain with the children's steps and dog bowl attached to it. The fountain, installed in the 1930s, was plumbed by Hubert Robinson.

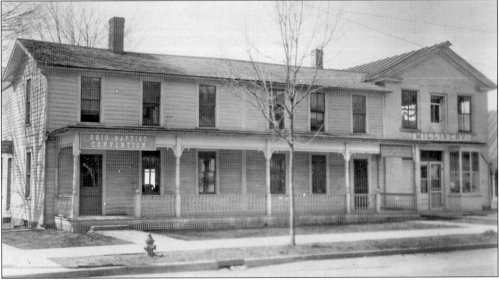

Baptist missionaries were an important part of Granville's religious history. Doane Hall housed the families of these missionaries in the early 20th century, but the Baptist Convention, which regulated missionary activities, was located on the southwest corner of Prospect and Broadway. In this photograph from the early 1900s, the convention's Granville headquarters is visible. A local lumber company occupied the building years earlier.

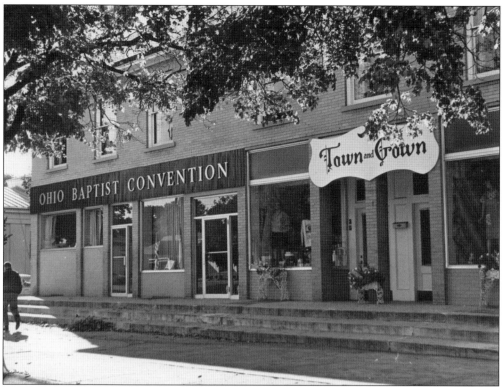

The Ohio Baptist Convention, based in Columbus, regulates the actions of the state's Baptist churches. Granville's convention satellite location was for years at the southwest corner of Broadway and Prospect. Prominent members of this branch of the convention included Allen Darrow and Rev. G.S. Sedgwick. In 1939, convention retirees were honored with a ceremony at the Granville Inn. A later incarnation of the convention building is seen here in the 1960s.

This 1895 photograph shows an earlier incarnation of the north side of the Broadway business district. The addresses of the buildings shown are, from left to right, 130, 132, and 134 East Broadway. In 1895, Brown's Notions occupied the building at 132. Today, Village Coffee Company is located in that spot. The Green Velvet boutique is now at 130, and Day y Noche Mexican Restaurant is at 134. Other popular merchants in this section of the business district included Squire Malone's Hats and Tailoring, George Piper's Meat Market, and the Granville Bank.

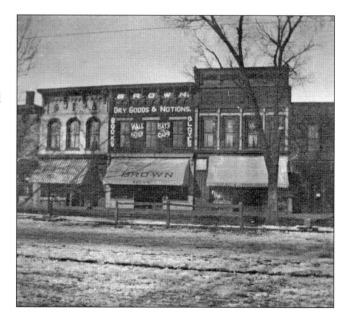

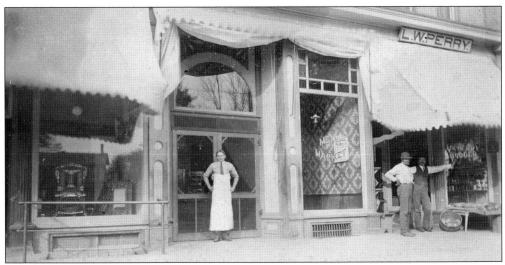

Seen here in 1905 are a couple of the businesses that were located on the northeast corner of Broadway and Prospect. To the right is the entrance to L.W. Perry Grocer. In 1904, a good-sized block of butter from Perry's cost only 18¢. Perry also had a bookstore, which he sold in 1888. Shown standing in front of Perry's are Samuel Jackson (left) and Will Chrysler. Dutch Piper, a local butcher, stands in front of the meat market. Jones Hardware is on the left.

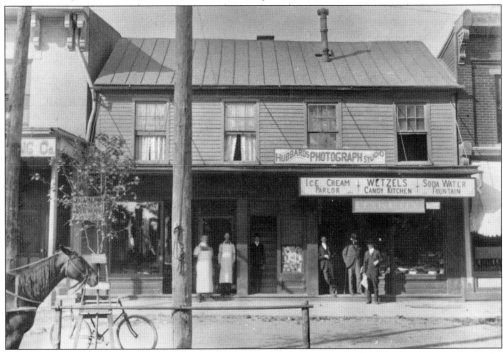

An early advertisement for Wetzel's Candy Kitchen referred to the shop as a "Headquarters for all confections, ice cream, and ice cream soda." Wetzel's was known for its "brick" ice cream. Horace C. Wetzel purchased the shop, located where Aladdin's is today, in 1893. Wetzel's had a candy wagon that traveled to small Licking County towns, and a restaurant was added to the shop in 1895. Wetzel retired from the candy business in 1899. In this mid-1890s photograph, he is wearing a suit and standing in front of the shop on Broadway.

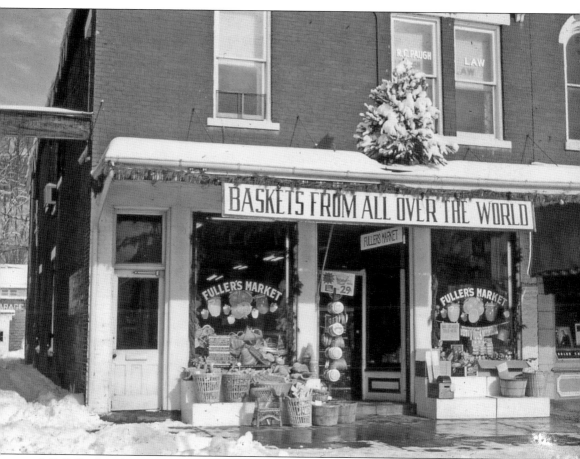

I.G. Fuller bought McCollum's Grocery Store in 1937, and it became Fuller's Market. The store sold meat and general grocery items. Fuller was part of a long line of Granville grocers that included L.W. Perry, Case & Hooley, H.M. Jackson, and Carter & Carter. In 1941, Fuller's had competition from the Red & White supermarket, Kroger, and the meat market of Woolard & Heil. Visible in this 1960s photograph is the small Christmas tree that Fuller's put on the roof of its store every year.

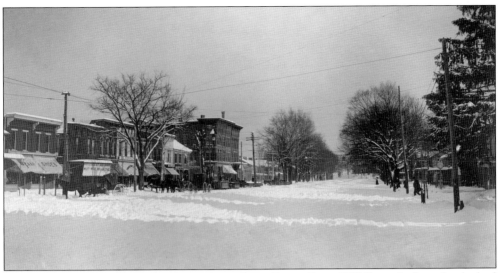

S.P. Tresize, a local photographer, opened a studio in Granville in 1905. Records show that he had been in business in Licking County since the 1880s. In 1912, Tresize got chemical poisoning and sold his Granville studio. Upon recovering, he got back into the photography business. This scene from the turn of the century was part of a series of photographs Tresize took after a particularly heavy snowstorm. The view is from the intersection of Broadway and Main Street. The north side of the East Broadway commercial block is on the left.

The intersection of Broadway and North Main Street is seen in this photograph taken by S.P. Tresize early in the 20th century. Still identifiable is the First Presbyterian Church (far left). The dog navigating the snowy street is about to pass the Centenary United Methodist Church (out of view at right). At the time of this photograph, the Methodist church, constructed in 1884, was relatively new, and the Presbyterian church had recently been remodeled.

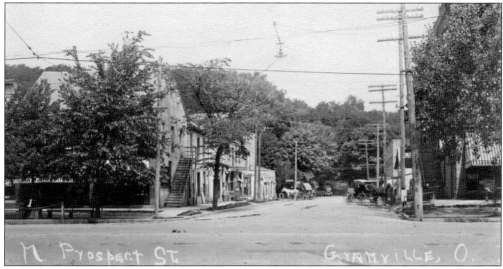

Prospect Street was always an integral part of the busy commercial area of downtown Granville. This photograph from the early 20th century shows the corner of North Prospect and East Broadway. Today, the building housing CVS Pharmacy stands where the Hotel Granville appears here, at far right. Other businesses in this section of town in the early 1900s included Simpson and Evans Plumbers, Tom Jones's Gun and Watch Shop, and DeBow's Marble Shop.

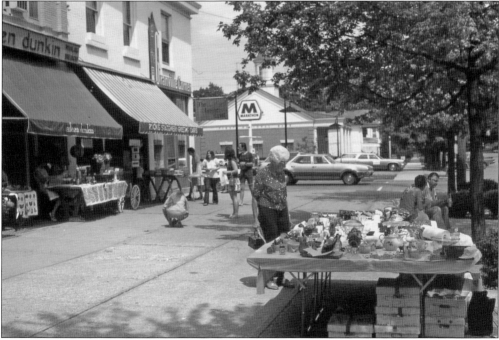

This 1972 photograph shows a sidewalk sale on the north side of the Broadway commercial district, looking east. Of particular interest is the Marathon gas station, which stood at the corner of Prospect Street and Broadway. The station was erected in 1967 on the site of the former Hotel Granville/Gregory Hardware building. It was intended to replace another Marathon station, just next door. The village council took only 40 minutes to approve construction of the second Marathon, which was torn down in the 1990s to make way for the current CVS building.

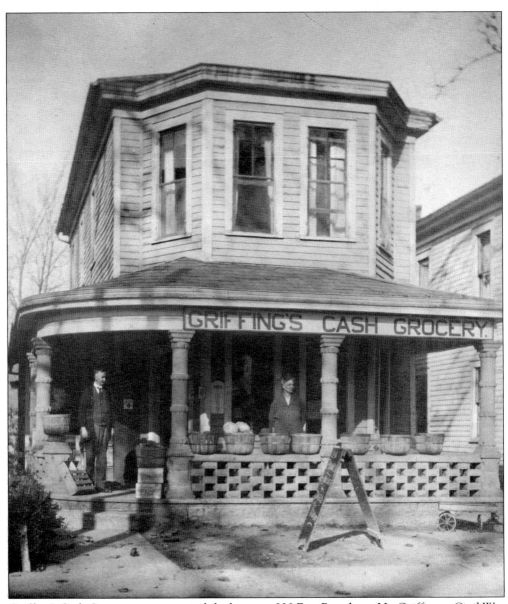

Griffing's Cash Grocery once occupied the house at 230 East Broadway. J.L. Griffing, a Civil War veteran, owned the business. He and his wife, Jane, lived in the upper part of the house and ran the store out of the building's first floor. The business, established in the late 19th century, sold produce and other items to Granville residents. Griffing sold the store in 1924. The front of the grocery and some of its wares are seen here in the 1890s. (Courtesy of Mary Everett.)

Dr. W.W. Bancroft graduated from the Ohio Medical College in 1827. He became interested in hydrotherapy and founded the Granville Water Cure in 1852. Dr. Bancroft lived in a house that once stood at 222 East Broadway. He erected three additional homes to the east of his house that became the water cure facilities. Hydrotherapy is the use of water to treat illness, ailments, and disease. The Granville Water Cure became well known in the medical industry. In 1865, Bancroft treated 187 patients, many of them from other states. Bancroft's residence and the buildings that comprised the water cure are seen here in the late 1800s.

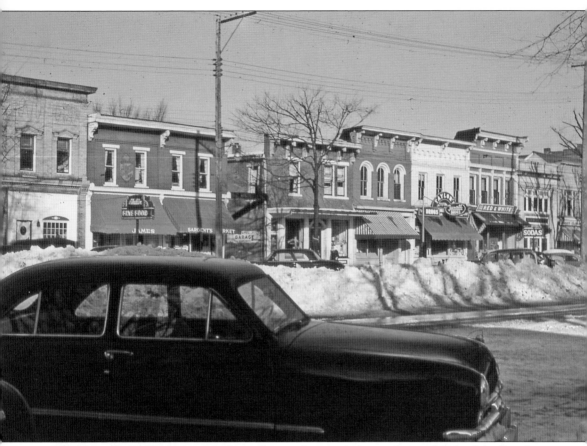

This November 1950 photograph shows the merchants inhabiting the north side of the Broadway business district. Taylor Drug is to the right of center, at 132 East Broadway, where the Village Coffee Company is today. The snow had accumulated during the Great Thanksgiving Storm, which buried Ohio in 10 to 30 inches of powder. Winds reached 40 miles per hour, and many buildings collapsed under the weight of the snow. Luckily, Granville managed to remain intact while the blizzard raged.

Five

GONE BUT NOT FORGOTTEN

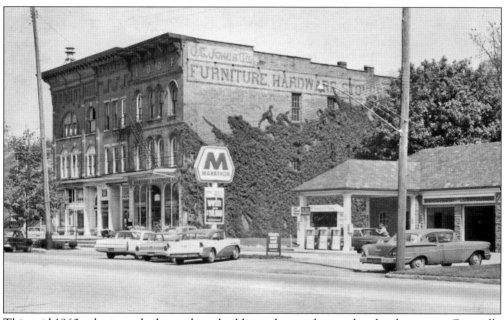

This mid-1960s photograph shows three buildings that no longer dot the downtown Granville skyline: Gregory Hardware, Hotel Granville, and the Marathon gas station. The hardware store, a large commercial structure on the corner of Broadway and Prospect Street, was built in the late 19th century. In addition to the hotel and hardware store, the corner building housed a number of commercial establishments, including the George Piper Meat Market, J.R. Crockett's Harness Shop, and the Schneider & Jones Bike Store. The building was torn down in 1967, and the site is now occupied by CVS. The Marathon was replaced by the building that currently houses Huntington Bank.

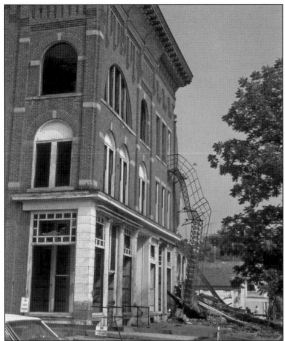

By 1967, city officials considered the Hotel Granville/Gregory Hardware Building a major fire hazard. Once the center of commerce in the downtown area, the building gradually lost tenants over the years and began to deteriorate. Gregory Hardware remained as the last occupant; when it closed, many residents felt sad. The store sold nearly everything except groceries, and many people took advantage of closing deals at Gregory's going-out-of-business sale. Demolition of the hulking commercial structure is seen here, in 1967.

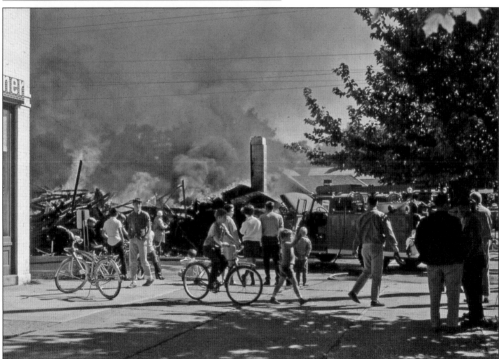

After the Hotel Granville/Gregory Hardware Building was demolished in 1967, the debris left behind was deliberately set on fire so that members of the Granville Volunteer Fire Department could gain practice by putting out the blaze. The rubble smoldered for a few days and was eventually cleaned up so that new businesses could be built on the site. Here, a crowd of locals gathers to watch as the fire rages.

Gregory Hardware was one of its longest-running tenants in the building on the corner of Broadway and Prospect. Purchased from George T. Jones in the late 1800s, the store did not close until the 1960s. Mitchell "Mike" O. Gregory is the best-remembered member of the Gregory Hardware family. He was an alumnus of Denison University and lived in town until his death in 1957. The Granville Hotel Building, located at 208 East Broadway, was torn down in 1967. A sign announcing the closing of Gregory Hardware is visible in the window.

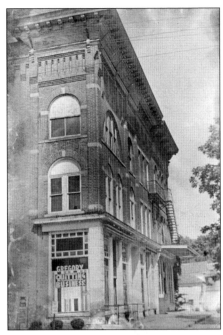

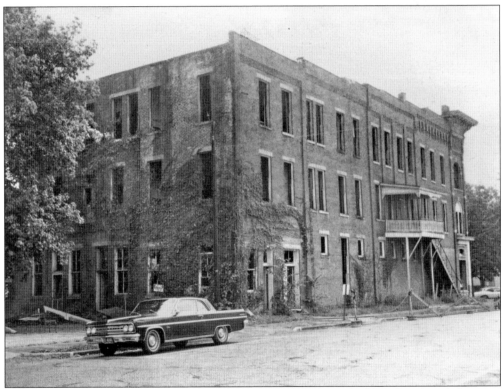

A rare view of the back of the Hotel Granville/Gregory Hardware building from North Prospect Street is seen here in the late 1960s. The building was torn down in 1967, and two additional structures have occupied the site since then. Today, this view would reveal the back of CVS and the drive-thru that leads to Huntington Bank.

Just to the south of Granville is Columbus Road (Route 16). Goose Lane is a street that is accessible from this route. At the turn of the 20th century, this area was farmland. Farms in this area belonged to Lute Woolard, Lor Edwards, and Eurie Loughridge. In 1898, the *Granville Times* reported that an eccentric named Charles Burton Phillips lived in the area. This 1920 photograph shows an example of Goose Lane housing and its inhabitants.

The homes on Goose Lane were large, but they were not as fine as the ones in the village. The large farmhouse seen in this 1920 photograph is typical of homes in the area during that time. Early farmhouses in Granville were constructed according to the New England tradition, which dominated the Midwest throughout the 19th century. It is quite rare to find one of these early houses in its original form, as most have been altered beyond recognition or even demolished.

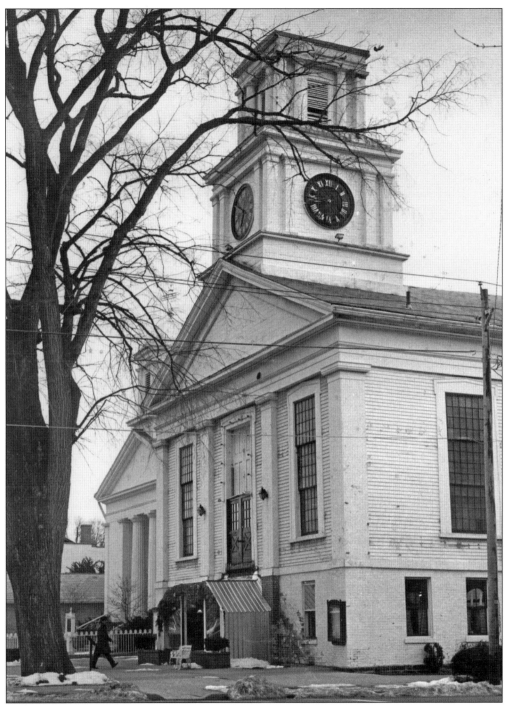

In 1849, approximately 100 years before this photograph of the Granville Opera House was taken, the building was located across Main Street, where it served the village as a Baptist church. It was moved to its final location, at the southeast corner of Broadway and Main Street, in 1882 and became the Town Hall. There was a time in Granville history when a majority of residents still referred to the building as the Town Hall, even though it had been an opera house for years.

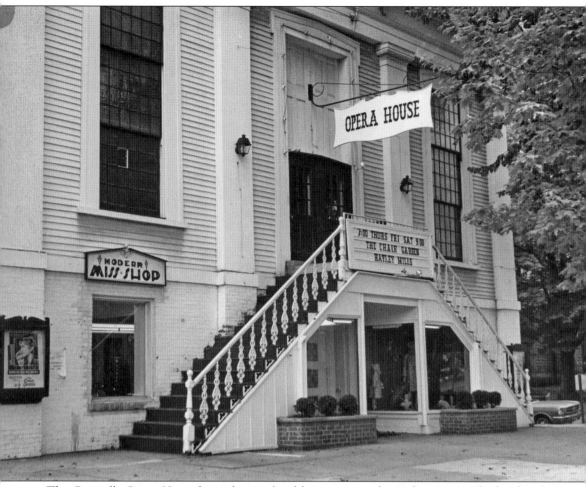

The Granville Opera House housed many local businesses in the 20th century. The height of the building's foundation was raised to accommodate government offices, such as the post office and the justice of the peace. The town council and the fire department also had offices in the Opera House lower level, and small shops were located there as well. The owners of the Apple Tree Auction Center in Newark had an antique store on the premises. This photograph was taken in the 1960s, when the Opera House was the location of the only movie theater Granville has ever had.

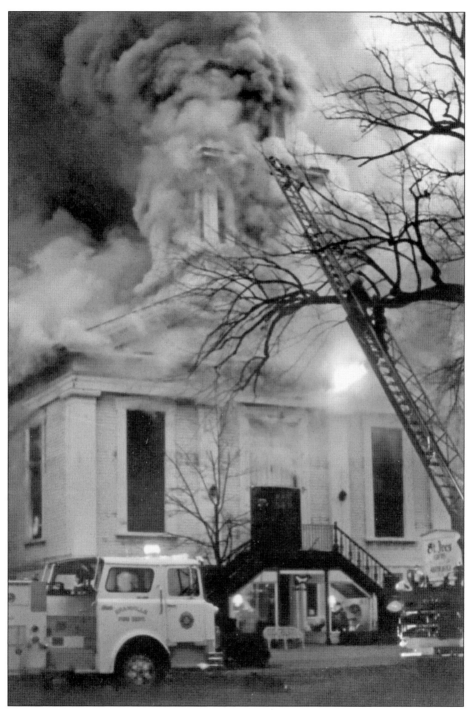

The Granville Opera House caught fire on April 7, 1982. It is believed that the cause of the fire was an electric heater. One of the most memorable moments for longtime Granville residents was seeing the gigantic structure burn. Here, members of the Granville Volunteer Fire Department and Newark Fire Department fight to keep the flames from spreading to St. Luke's Episcopal Church, which sits dangerously close to the devastation. (Courtesy of Dr. Robert Raker.)

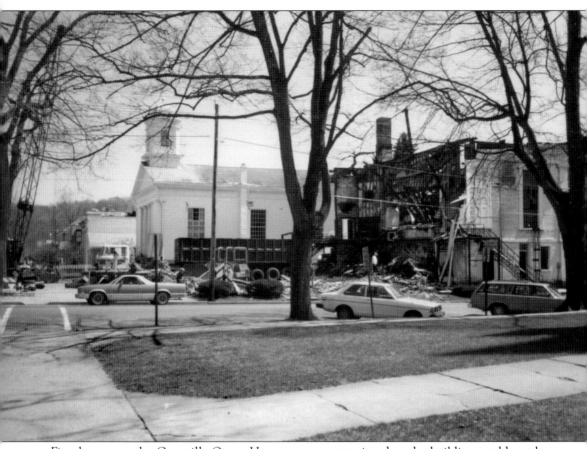

Fire damage to the Granville Opera House was so extensive that the building could not be saved. If not for the forward thinking of professor Lee Larson, the damage to the town could have been much worse. A few years prior to the blaze, Larson had convinced village officials to update the downtown water line. This photograph from the fall of 1982 shows how crews worked to systematically tear down what was left of the Opera House without disturbing St. Luke's Episcopal Church.

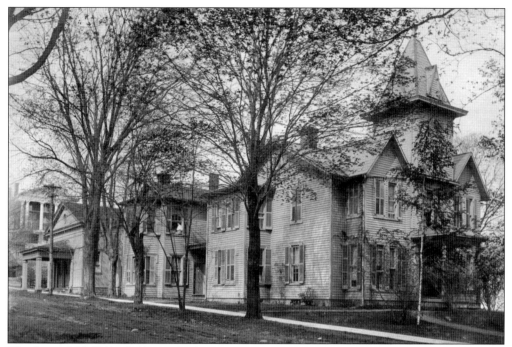

The Recital Hall (far left) was built in 1897. It was part of a group of educational buildings located near the corner of Broadway and Cherry Street. The buildings were originally part of the Shepherdson College for Women, which was known as the Female Seminary until 1899. Named after Rev. Daniel Shepherdson, the college provided Granville women with an education equal to that of men. In later years, young men from Denison took singing classes at Shepherdson. The Recital Hall was eventually torn down by Denison University to make room for Burke Hall, which was built in 1973.

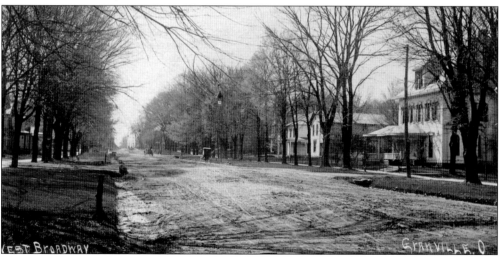

Monomoy Place can be seen on the far right in this photograph from the turn of the 20th century. To the left of Monomoy are two smaller houses, Case Cottage, next to Monomoy, and Baker Cottage. Both houses were used as dormitories for male Denison students and, in later years, as faculty housing. The cottages were torn down after World War II, and the site on which they stood is now part of the yard belonging to Monomoy.

Dr. Clyde J. Loveless was a successful man in town. Aside from being a practicing physician, he was on the draft board for Licking County in 1917, and served as Granville's mayor in the 1930s. Due to his social status, Dr. Loveless's activities were closely monitored. Of particular interest were his cars, which the *Granville Times* reported on regularly. In 1915, he bought an Empire Touring Car, and in 1917, he bought a new Dodge Runabout. Loveless's former residence at the corner of Broadway and North Pearl Street is seen here in the 1920s. The parking lot for the Granville Inn now occupies the spot where this house once stood.

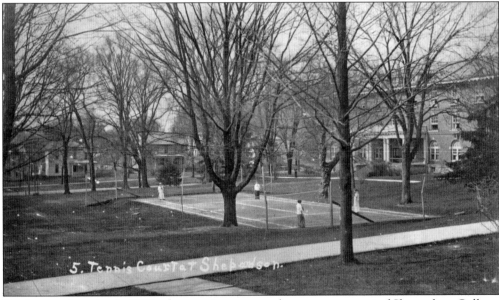

Denison students in the 1920s play tennis on courts that were once part of Shepardson College. The courts, located between Chapel and Burton Halls, were used by the university until 1927, when new courts were created to the north of Beaver and Sawyer Halls. In 1899, the manager of the Shepardson courts was Platt Lawton. The *Granville Times* reported that tournaments were held on the courts in 1895 and 1896. And, in 1914, Stella Case Bell won a doubles tournament in Queens, New York, after months of practice at Shepardson.

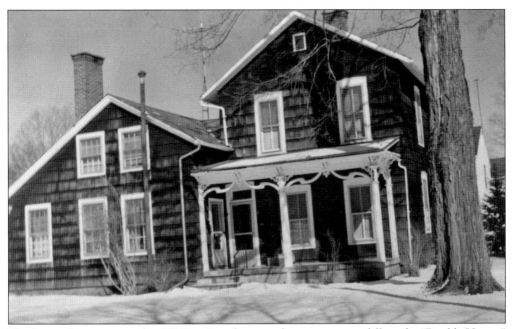

The house that once stood at 357 East Broadway was known to townsfolk as the "Double House." Built in the late 19th century, the structure received its name because it looked like two houses put together. As with many Granville buildings, this one caught fire in the late 1970s. It became an eyesore and was finally demolished in 1981. The parking lot of the Granville Inn now occupies the spot where it once stood.

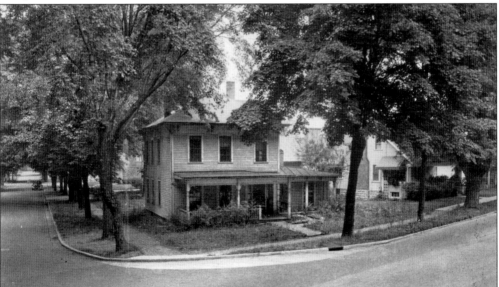

This photograph of a house on the northeast corner of East Broadway and Granger Street was taken on August 6, 1936. In the late 1800s, the house was owned by Frederick Eno, a tinsmith and carriage maker. He worked for Jones & Sons Hardware. F.H. Buxton owned the property after Eno. Buxton repaired watches and owned a jewelry store in Mount Gilead at the end of the 19th century. The house was eventually razed by the Granville Board of Education; the administration building now occupies this spot.

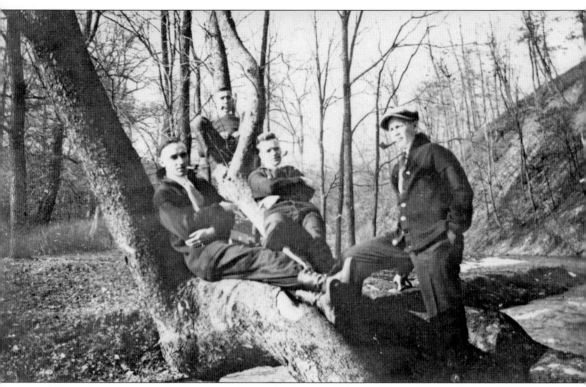

These fine young gentlemen are posing at the Proposal Tree in Spring Valley Park in 1925. The tree received its name because so many couples got engaged on that spot. In the early 1930s, it became part of the Spring Valley Pool grounds. These boys may have made a visit to the tree with their own girls at some time. On this day, however, they seem much more interested in smoking their pipes and enjoying bachelorhood.

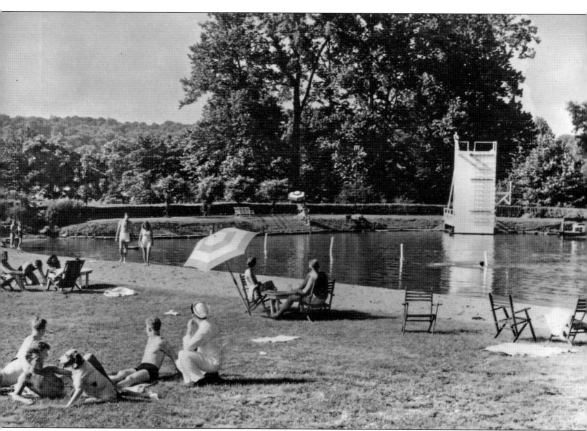

In 1933, Spring Valley owners chose a desirable spot on which to create a pool for park visitors. The pool quickly became a popular hangout and remained so until 2005, when it was finally filled in. Here, sunbathers and swimmers gather at the pool to escape the summer heat and enjoy a day of leisure in 1944.

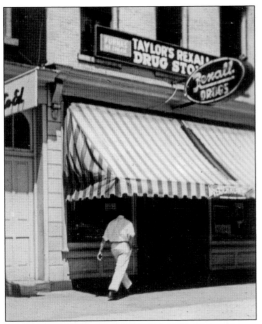

There have been several pharmacies in Granville over the years. Early drugstores were owned by W.H. Ports, Dr. O.J. Wood, J.W. Ackley, Bryant & Co., and W.P. Ullman. Taylor's Rexall Drugs was located at 132 East Broadway, in the downtown commercial block, for decades and became a popular hangout thanks to its soda fountain. Taylor purchased the store from W.P. Ullman in 1910. It was relocated to the corner of East Broadway and Prospect Street in the late 1990s. CVS took over that property in 2005, to the chagrin of many longtime residents.

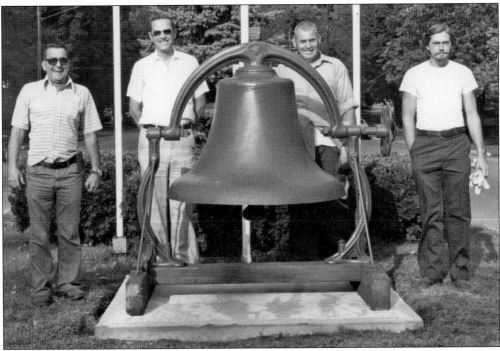

The Opera House Bell was not damaged by the fire that destroyed the rest of the building in the spring of 1982. It had been removed for restoration not long before the blaze and was sitting safely off-site as the rest of the Opera House burned down. In 1983, the newly restored bell was installed in its current location near the sidewalk on the corner of Broadway and Main Street to mark the entrance to the newly created Opera House Park. Among the men shown here with the bell are two popular members of the village community, Ralph Blackstone (left) and Buck Sergeant (second from left).

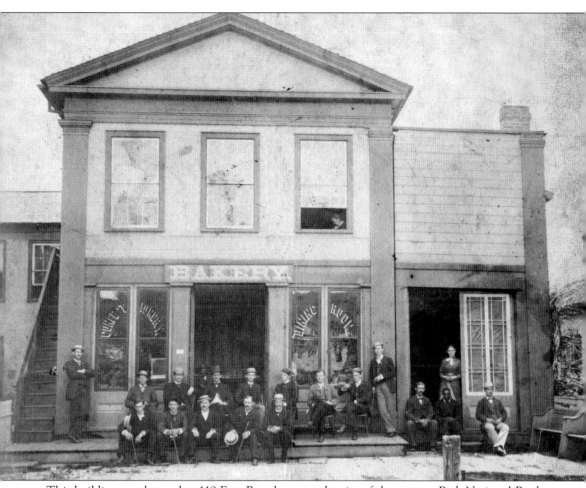

This building was located at 119 East Broadway, on the site of the current Park National Bank building. It was a multiuse structure comprising a boardinghouse and, in the late 19th century, at the time of this photograph, a restaurant. The structure was razed in the early 1920s to make way for the new brick bank building. Of note is the house at the far left of the photograph. It belonged to Jacob Little, the pastor of the Presbyterian Church and author of the first history of Granville. Little was a well-respected member of Granville society and served the Presbyterian Church for over 40 years.

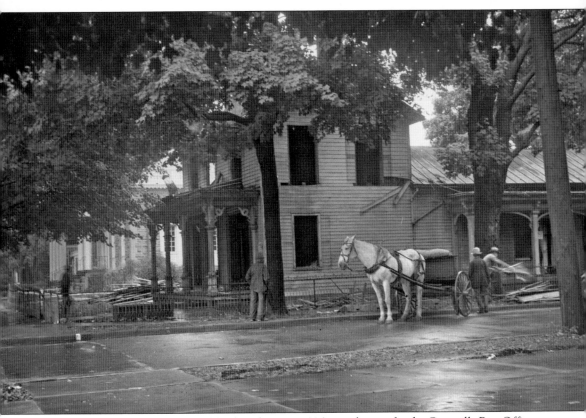

The Smith House is being prepped for demolition in 1936 to make way for the Granville Post Office. Once belonging to Lucretia B. Smith, the home was located on Broadway between Prospect and Pearl Streets. The original portion of the structure was built sometime in the mid-19th century. A rear addition and porch were added at a later date. Of interest in the photograph is the horse pulling the fire hose, brought to the demolition as a safety precaution.

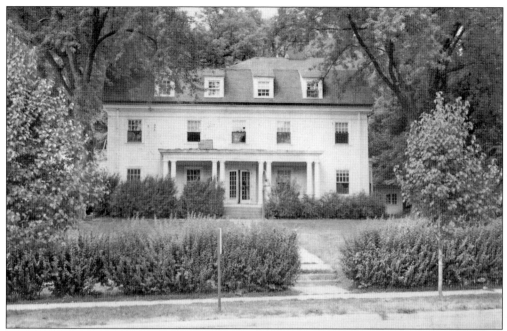

Denison University acquired the Fannie Doane house in 1954 and used it as a home for married students and faculty members until it was torn down in 1974. William Howard Doane also gave the university a building known as the Old Doane Library. It was demolished in 1934. The cornerstone of the original 1878 structure now decorates the landscape in front of the current Doane Library. Shown here is the Fannie Doane house shortly before it was demolished.

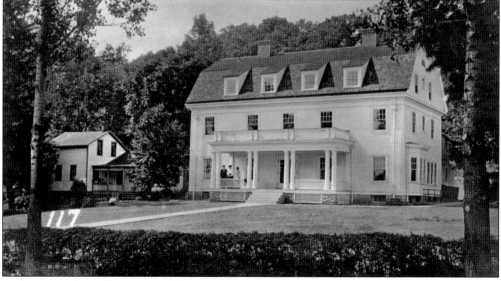

Built in 1909 by William Howard Doane and named after his wife, Fannie, this house was never actually inhabited by its namesakes. The first owner was the American Baptist Foreign Mission Society, which used the house as temporary living quarters for the children of deployed Baptist missionaries and for orphans whose parents were killed while on a mission for the church. This early 1900s photograph shows unidentified Baptists standing on the porch of the house soon after it was built.

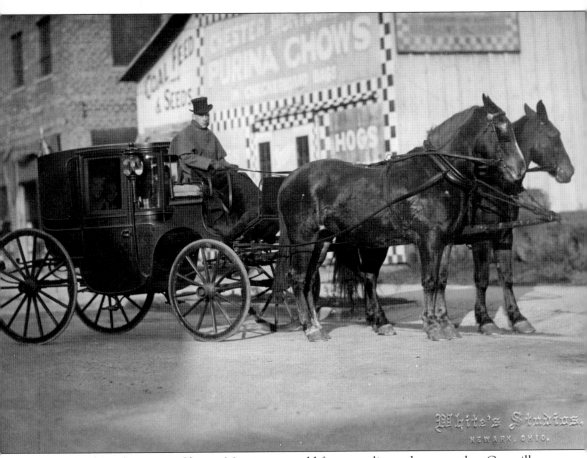

In the early 20th century, Chester Montgomery sold farm supplies and even coal to Granville residents. His early feed outlet was in the rear of Geach's Hardware on Broadway. In 1917, he purchased property on North Prospect Street and opened his own feed store. Montgomery sold Purina products, and he painted the outside of his building and his company truck in the checkerboard design of Purina's feedbags. This 1920s photograph provides a view of the paint scheme. Montgomery eventually leased the business to Ernest King in 1939. The building is no longer there, and the site is now occupied by the First Federal Savings and Loan Association behind CVS.

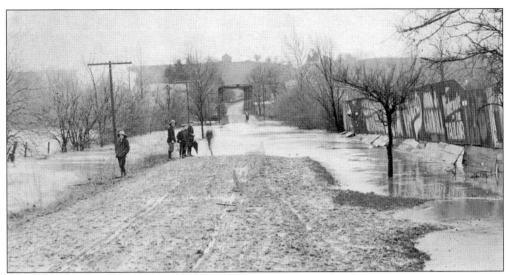

Flooding was a large problem in Granville during the late 19th and early 20th centuries. Rarely did a year go by without Raccoon Creek overflowing. Located on the south side of town, the creek would overflow, causing serious problems for residents and business owners on South Main Street. Here, teenagers survey the height of the water in the early 1900s. The area just behind the billboard is where the Granville Lumber Company and the old Toledo & Ohio Central railroad station are currently located.

In summers past, the Denison University theater department would set up a big blue tent and perform for Granville residents. The tent would be erected on the lawn near the current site of Burke Hall. A small and colorful ticket booth was employed for students to collect entry fees from theater patrons. As this 1960s photograph reveals, the booth was a permanent structure that remained standing through the cold winter months.

The corner of South Main and Elm Streets is seen here in the 1950s. Featured prominently in this photograph is a house that once stood on the northeast portion of the corner, at 177 South Main Street. It was torn down and replaced by the combination business/apartment building that now occupies the site.

This dilapidated structure was a mill that sold lard to Granville residents at the turn of the 20th century. Before the advent of cooking oil, lard was used for baking and frying. In this mill, fat from the loins and back of pigs would be heated for hours in a large pot until it liquefied. It was then put into canisters to cool. Lard fell out of favor when vegetable oil became popular. This building had already been out of use for several years by the time this photograph was taken in the 1930s.

Located near the corner of Thresher and Burg Streets, the Bio Pool Falls was intended as a learning environment where students could observe organisms in their natural habitat. Unfortunately, the pool would not hold water, and few samples could be taken from its waters. In 1953, Smith Hall was constructed, and dirt from that building's excavation was used to fill in the Bio Pool.

Six

THE WAY THEY WERE

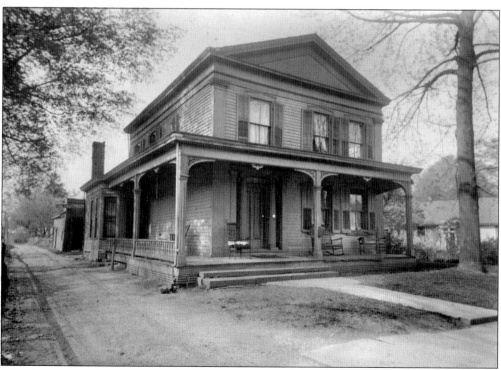

This house, seen here in the early 20th century, once belonged to Dr. Edwin Sinnett and his wife, Sarah. It originally stood on the present site of the Granville Public Library, at 217 East Broadway. It was moved when the library was built, and was moved a second time when the library expanded. It now sits at 126 South Prospect Street. The house is seen here on its original lot. The fence surrounding the Avery-Downer property can be seen on the far left.

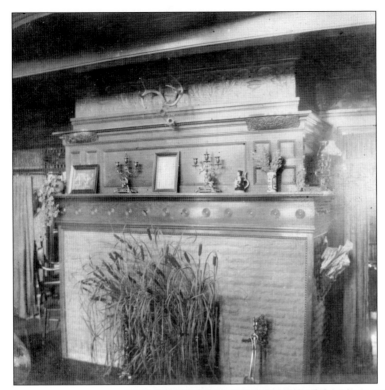

Charles Browne White, a Denison University professor and writer, and Clara Sinnett White, a music teacher, lived in the large stone house at 537 Mount Parnassus Drive. When the house was built in 1889, it was the only structure on the hill, affording a commanding view of the village and surrounding township. The interior of the house was as grand as the exterior (see page 103). One of the house's many fireplaces is seen here in the early 1900s.

The Sinnett-White house is still located atop Mount Parnassus, but trees and newer homes now obscure it. The rear of the home is visible from Mount Parnassus Drive to anyone passing through the hilly neighborhood. This photograph, taken in the early 1900s, reveals the room containing the massive stone fireplace in the previous image.

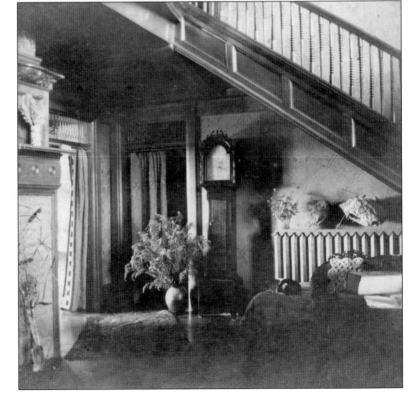

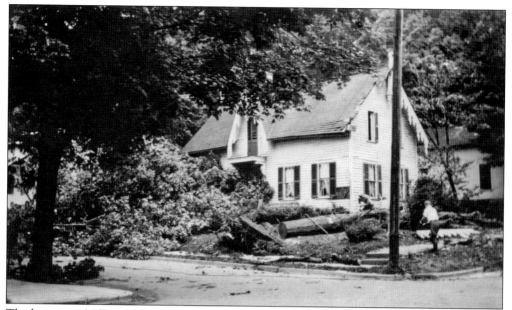

The house at 184 East College Street is seen here in the 1930s. It still looks much the same, but the shutters, original windows, and decorative bargeboard trim are gone. There were several big storms in the 1930s, and this property sustained damage during one of them. Other damage included the destruction of a porch on West Maple Street and the splitting apart of a new barn belonging to Edward Jones.

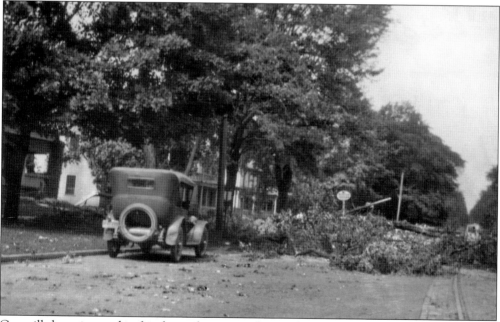

Granville has witnessed its fair share of storms, and storm damage, over the years. In 1929, a strong windstorm blew through town, uprooted trees, broke the plate glass window at Star Grocery, and tore up the roof at Morrow Dry Goods. Apparently, the wind was so strong that it all but demolished J.E. Hutchins's barn as well. Here, a tree and debris lay across Broadway in front of the Buxton Inn prior to the cleanup process.

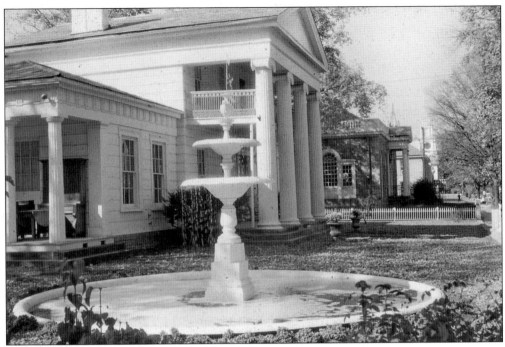

The Avery Downer house at 221 East Broadway has been known as the Robbins Hunter Museum since 1981. Built in 1842, this Greek Revival building was home to the Avery, Spellman, and Downer families. In 1903, it became a fraternity house and remained so until 1956, when Robbins Hunter Jr. moved in. Hunter collected antiques and architectural salvage. The fountain and pool in the foreground of this 1970s photograph was one of his finds. It was eventually moved to the Buxton Inn property, where it continues to operate.

This small bungalow at 232 Granger Street was constructed from plans created by Sears, Roebuck & Company. From 1908 to 1940, Sears distributed home plans in a publication called *The Sears Modern Home Catalog*. Materials used in the construction of these homes were shipped directly to the building site. Sears was considered an innovator in modern home design, introducing new building materials such as drywall and asphalt shingles to buyers across the country.

The house at 122 North Pearl Street, seen here in the late 1960s, was built in 1915. The house is not as significant as the site it occupies. At the turn of the 20th century, the local blacksmith, Byron Evans, worked out of a building that stood where this house does today. Evans and his son Charles were well known in town.

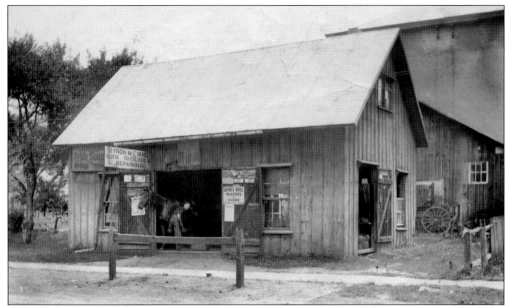

This photograph, taken at the turn of the 20th century, shows the former occupant of the site at 122 North Pearl Street. The Evans Blacksmithing shop at this location was closed some time before the house was built. Byron Evans, the shop's owner, retired from the business in the 1920s. However, the *Granville Times* reported that Evans was looking to get back into blacksmithing by the mid-1930s.

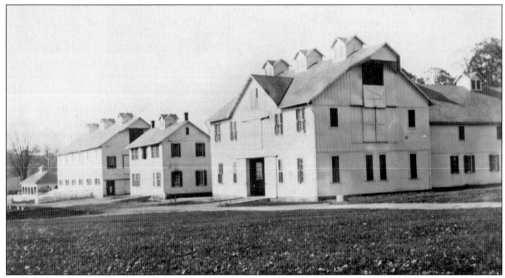

Seen here in the early 1920s are a few of the buildings that were once part of the Bryn Du Farm, which was formerly located on the property surrounding the Bryn Du Mansion at 537 Jones Road. John Suptin Jones, a prominent businessman and creator of the Granville Inn and Golf Course, operated a cattle ranch on the property. Water that supplied the farm and nearby mansion was originally pumped from two springs on the adjoining farm of Dave Watkins. Chester Cook and Henry Dyker ran the farm after Jones's death. When they died, so did the farm. Two of these buildings were immediately torn down when William and Ortha Wright bought the property in the 1960s.

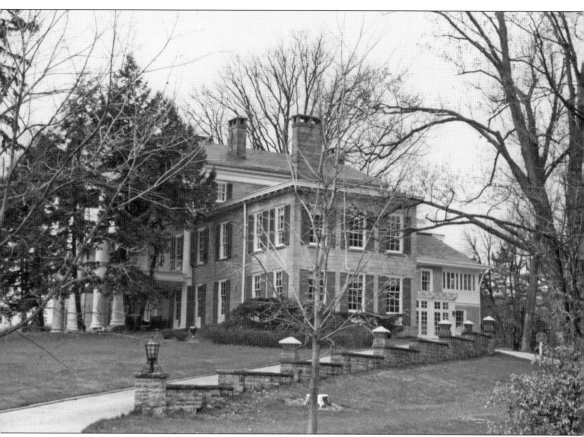

Bryn Du Mansion was once known as McCune's Villa. It was built in 1865. The villa's first owner was Henry D. Wright. J.S. Jones, a coal and railroad magnate and the developer of the Granville Inn, purchased McCune's Villa in the 1920s. An extensive remodeling project eliminated the home's Italianate elements and replaced them with Federal-style additions. Although he changed the entire look of the mansion, Jones utilized sandstone from the same on-site quarry that Wright employed to build the original villa.

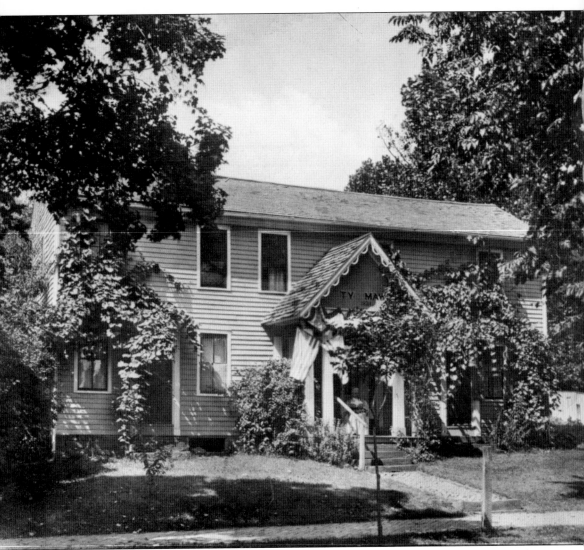

Ty Mawr, located at 235 North Pearl Street, is also recognized as the Samuel and Charles Langdon House. Built in 1834, it was used by Samuel Langdon, a well-known abolitionist, as a stop on the Underground Railroad. Langdon was a delegate at the Abolitionist Society Convention, held in Granville in 1836. By the end of the convention's second day, abolitionists, including Langdon, were involved in a violent fight that became known as the Granville Riot. The house is seen here at the turn of the 20th century.

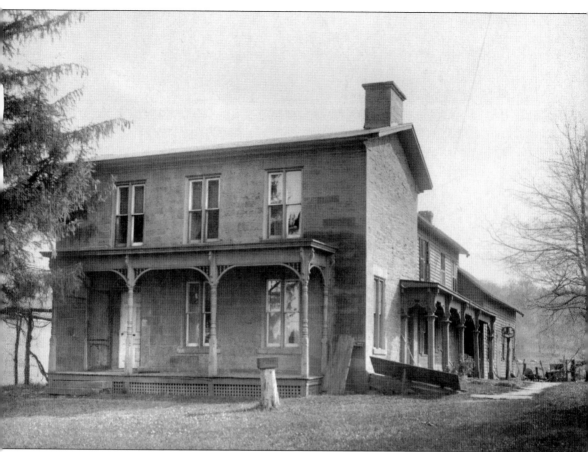

The home of Ashley Bancroft at 555 North Pearl Street was built in 1834. Bancroft was a well-known abolitionist in Granville, and the house served as a stop on the Underground Railroad for a number of years. Bancroft built a barn on the property that became known as the "Hall of Freedom" because it served as the meeting place for the first antislavery convention in central Ohio, held in 1836. Abolition was not popular with all Granville residents, and tensions ran high the night of the convention. Opposing groups met in a violent confrontation, now known as the Granville Riot, later that evening.

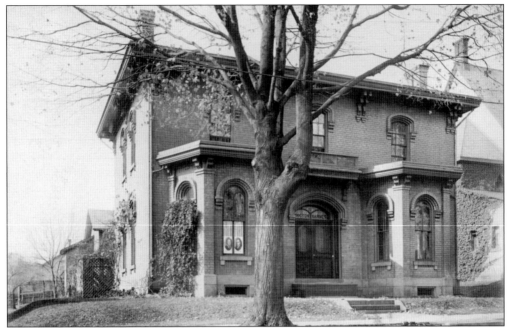

The house located at 121 South Main Street was the site of the former Granville Lifestyle Museum. Created by Hubert and Oese Robinson, the museum, which was also their home until 1983, provided a showcase for the couple's possessions. The museum closed in 2011, and the items located within it have been relocated to the Granville Historical Society building at 115 East Broadway. Seen here in 1911, the house bears the name of its first owner, Dr. Ernest Barnes, a former mayor of Granville. Barnes had the house built for himself and his wife, Louisa, in 1861.

Snapshots of Oese Robinson's life were preserved in the former Granville Lifestyle Museum at 121 South Main Street. Oese's widowed mother lived for some time at 327 East Broadway, in the home pictured here. Oese's parents were Mr. and Mrs. Levi Roley. This photograph was taken in the 1920s, about 10 years after Oese married.

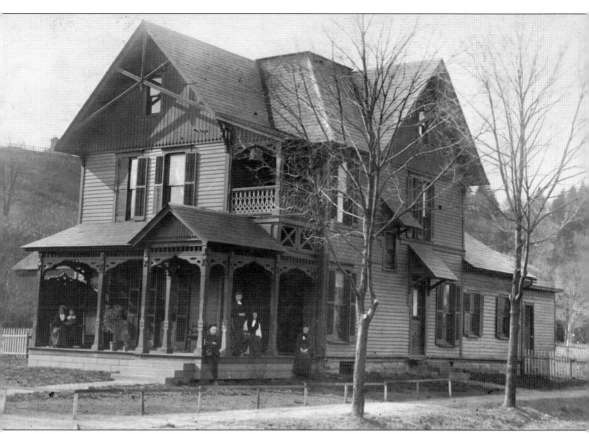

The house located at 240 East College Street was originally built for Charles Webster Bryant, town druggist and founder of the Granville Historical Society. The house was given the name Pen Coed, which is a Welsh moniker meaning "head of the woods" or "treetops." Seen in this photograph, taken at the turn of the 20th century, when the Bryants boasted ownership, are, from left to right, Rose Hudson, Mary Hayes, Emma Jewett, Fitch Bryant, Miriam Bryant, and Mary Fitch Bryant Abbott.

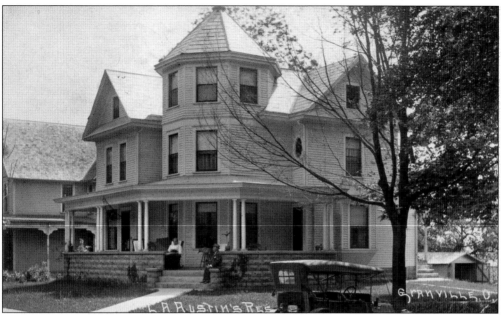

This house at 205 South Prospect Street was built in 1876 and served as the home of L.A. Austin, local jeweler, at the turn of the 20th century. His jewelry store was located in the commercial block along the south side of Broadway. There was a fire at the store in 1886, and Austin retired from that line of work in 1898. He eventually became Granville's postmaster, retiring from that job in 1915. The home is shown here in the early 1900s.

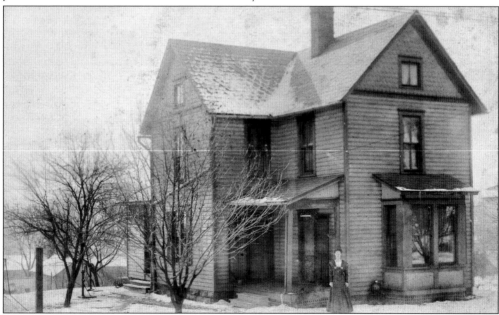

The house at 126 West Maple Street is seen here in the 1890s, with a resident standing by the front porch. The house is of a vernacular style called Tri-Gabled Ell or Gable Front and Wing. This type of house often had a shed-roofed porch resting in the center of the ell. There are many houses in town, particularly on Granger Street, that fall within this architectural category. Where open land once surrounded this house, there are now homes on either side of the building.

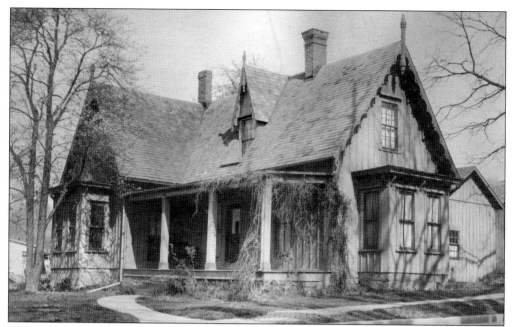

This house at 404 West Broadway was built in 1850 by craftsman Amos Montanya. The first inhabitants included Rev. Alvah Sanford and his son Solomon. In later years, the structure was nicknamed "Solomon's Temple" in honor of the reverend's offspring. Sanford, a successful man, bought the Granville Hydraulic Company in 1860, and served as a preacher for St. Luke's Episcopal Church. Later residents of the home included Kate Rugg, who allegedly tried to set fire to a telephone pole in town. This photograph was taken in 1932.

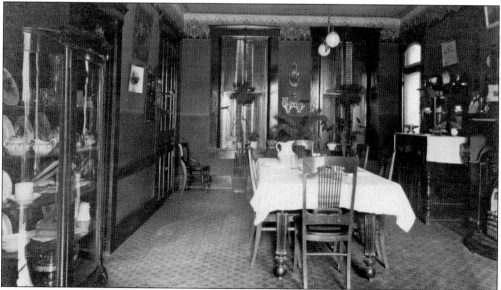

Dr. Ernest Barnes, who practiced medicine in the late 19th and early 20th centuries, had offices in various cities in Ohio, including the towns of Hebron and Colton. In 1908, he moved his practice into his home at 121 South Main Street. According to the *Granville Times*, Dr. Barnes sold the house in 1911 under foreclosure. This photograph, taken between 1909 and 1911, provides a glimpse of the Barnes's dining room furnishings.

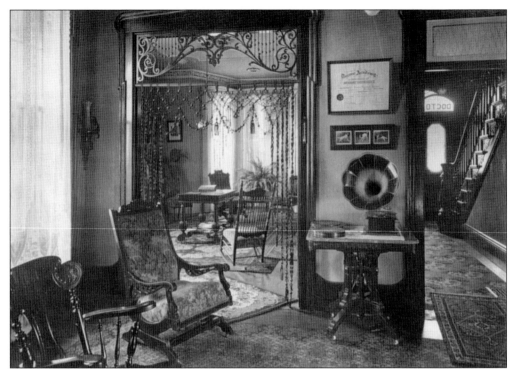

Dr. Ernest Barnes and his wife, Louisa, lived at 121 South Main Street. The house eventually became the Granville Lifestyle Museum of Hubert and Oese Robinson. Dr. Barnes was the vice president of the Ohio State Medical Society in 1905 and became the mayor of Granville in 1909. This photograph, taken between 1909 and 1911, provides a rare view of the interior of one of Granville's most stately houses. Furnishings in two of the first-floor parlors are depicted here.

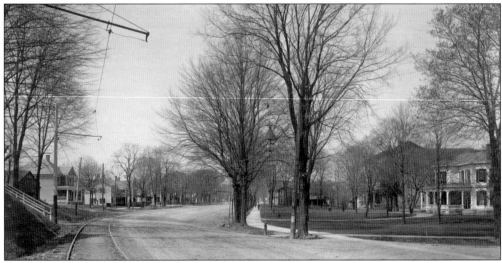

The east side of Broadway is seen in this 1900 photograph. The photographer was standing at the base of Mount Parnassus, looking toward the downtown area. The Buxton Inn is to the left (second building), as are the interurban tracks running along the dirt road that was Broadway. Travel on such roads could be treacherous after a rainstorm, with potholes and divots to deal with. However, when the weather was good and the dirt hard-packed, travel was not unbearable.

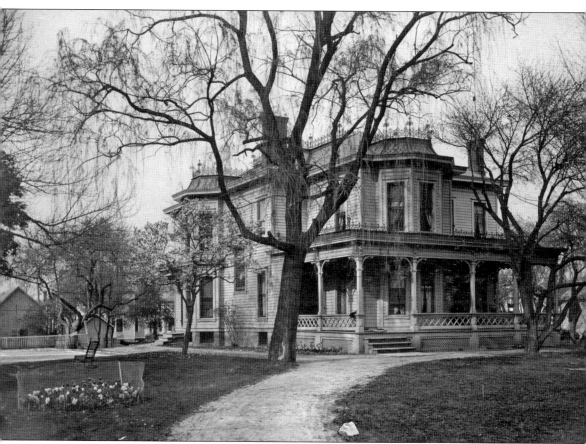

The College Town House is seen here in the early 1900s. The house was built in 1855 and used as a primary residence by W.P. Kerr, principal of the Granville Female College. It was used as a fraternity building from 1899 to 1929. The house, still standing today, is used as Denison University faculty apartments, and its formal rooms are rented out as meeting and event space for community functions.

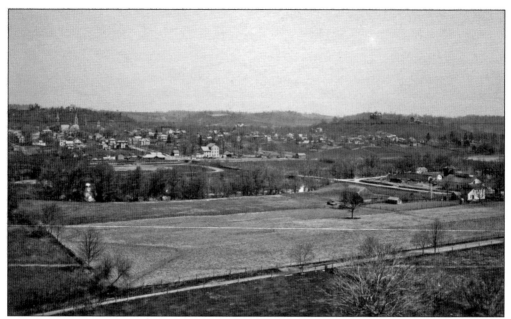

This 1923 photograph shows the area south of town, before Route 16 was constructed. The view is from Flower Pot Hill, which rises to the west after one crosses Route 16, via Route 37. The large patches of land in the foreground have been replaced by the freeway exits that provide access to Granville from Route 16. In the center is the former Town Playing Field. Directly behind it, surrounded by a running track, is Denison University's old Beaver Field.

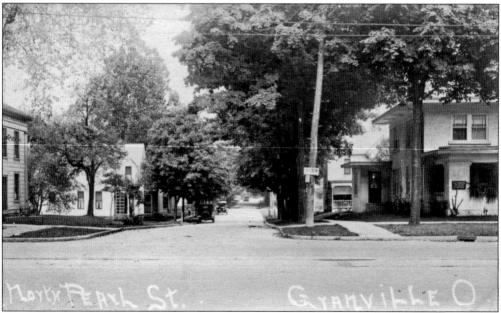

This photograph can be dated to the early 20th century, because the house on the right, belonging to Dr. Clyde Loveless, was torn down and replaced by the parking lot of the new Granville Inn. The house on the far left is still standing and being used for commercial purposes. This intersection has not changed much. If not for the presence of the Loveless house and the period cars on the street, there would be little indication that this is not a recent photograph.

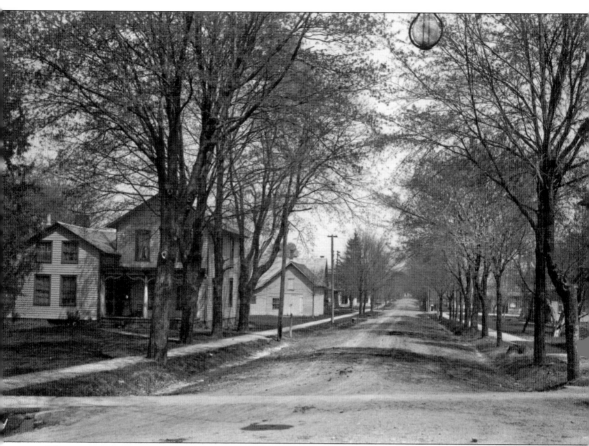

The intersection of Granger Street and Broadway is seen here at the turn of the 20th century. Streets in Granville were not paved until around 1916. Prior to that, dirt roads were the norm. To the left is the home known by residents as the Double House. That site is now occupied by a parking lot. At the very top of the photograph is an arc light. This system of early electric lighting replaced gas street lamps in the early 1900s. Just visible on the far right is the former F.H. Buxton house, pictured in full on page 77.

The *Granville Times* first mentions the hill now known as Mount Parnassus in 1881. Named after the home of the Muses in Greek mythology, sacred to Apollo, and used by the Dorians, the hill used to be just as empty as Sugar Loaf was after its trees were milled. The first house built on Mount Parnassus, constructed in 1889, belonged to Dr. Edwin Sinnett. Slowly but surely, more houses followed, and a full-fledged neighborhood exists there today. This photograph was taken in the late 19th century. The second house built on the hill, belonging to the McClain family, is partially visible on the far right.

At the turn of the 20th century, Granville's premier park was Spring Valley. Located on farmland south of town, where Columbus Road is today, the park became the site of picnics and romantic strolls. The Baptist Church had its annual picnic there in 1894 and 1895, the Camp Fire Girls held a retreat there in 1915, and the Granville Yacht Club introduced young members of the most revered social set there in 1935. Here, a young couple (far right) sits and enjoys the scenery around 1900.

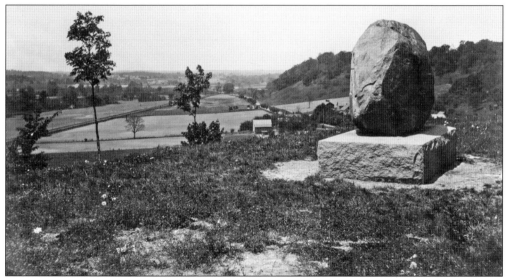

Sugar Loaf, the hill that borders the west side of the village, was originally called Stone Hill, because it provided early settlers with sandstone for building. Trees on the hill supplied wood for construction, and, once the trees were gone, the land was used as a pasture for livestock. With no trees to impede the view, the entire village and surrounding township was easily visible from the top of the hill. When covered in snow, the hill resembles a Colonial confection called a sugar loaf, thus the formation's current name. This 1905 photograph shows the newly installed boulder monument and the vast land to the south of the treeless hill.

The west end of East Elm Street is seen here in 1949. Across from the current Elm's Pizza location were three houses. The house at 120 East Elm once belonged to Gerard Bancroft. It also belonged to Flossie and Ted Preston. In earlier years, it was the home of a woman named Anna Lewis, who covered the structure in dark red roses. The roses that grew on the Lewis house are well remembered by longtime Granville residents. The two homes on either side of the Preston/Lewis house were demolished to make room for the Park National Bank drive-thru entrance and exit in the 1960s.

The house at 327 East Elm Street has been vacant for many years. It is part of the Buxton Inn complex and is currently used for storage. The home is seen here in the 1930s, when it was a single-family residence. Rumor has it that John Davidson, host of the 1980s television shows *That's Incredible* and *Hollywood Squares*, lived at this address. Davidson is a Denison University alumnus who lived in Granville during the early 1960s.

John J. Hughes was a contractor in Granville during the late 19th century. In 1881, he established a lumberyard on the site of the current Granville Lumber property. Hughes lived in several different houses in town. He was on Morning Street in 1884, and he moved to this house on Spellman Street in 1890. In 1892, the *Granville Times* reported that Hughes had installed an electric lamp in the Spellman Street house, shown here in the early 1900s.

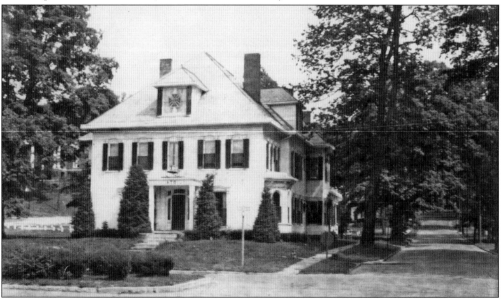

Monomoy Place, located at 204 West Broadway and named after a small island off the coast of Massachusetts, was built for Dr. A.K. Follett in 1863. J.S. Jones, developer of the Granville Inn and Golf Course, acquired the house in the 1920s and gave it the Monomoy name. In 1935, Denison University bought the house and used it as temporary housing for female students. It now serves as the home of the president of Denison University.

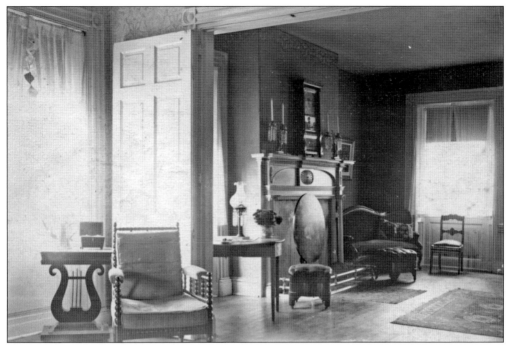

The Lucius D. Mower House, also known as the Mower-Darfus House, was built in 1824 by Mower himself. Colonel Mower has been called the most prominent Granville businessman of the 1830s. A merchant, financier, and master craftsman, he was also involved in the development of the Ohio & Erie Canal. In 1823, Mower built the Ahab Jinks home at 124 South Main Street and caused quite a controversy when he showed up for work on a Sunday. His own home, located at 233 East Broadway, is in the National Register of Historic Places. A rare glimpse of the home's interior is seen here at the turn of the 20th century.

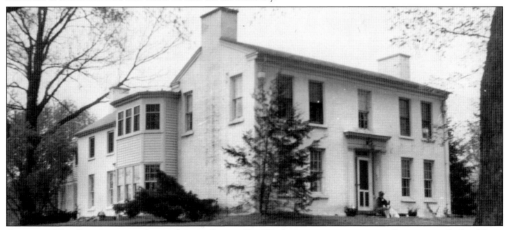

Spencer Wright was an early settler in Granville. He became a tanner, working out of a building located on the family property at 635 Newark-Granville Road. A tanner's job is to transform rough animal skins into leather. The Wrights were very successful in this industry, and Spencer was eventually able to build an additional house, which he called Maplewood, just down the street from the tannery. Located directly east of the St. Edward the Confessor Church parking lot, Maplewood remains a grand house to this day. This 1948 photograph shows how little the exterior of the structure has changed over time.

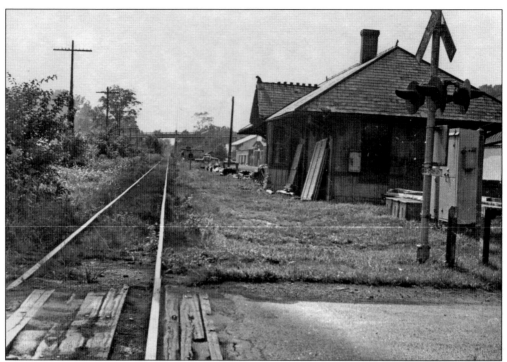

The train depot at 124 South Main Street was once part of the Toledo & Ohio Central Railroad. It was part of the Penn Central Railroad when it was finally closed in 1976, after nearly 100 years as a stop. This photograph was taken shortly after the depot's abandonment. It sat in a state of disrepair for years, but was nominated for inclusion in the National Register of Historic Places in 1980. In 2010, the depot received a new foundation, and restoration of the structure has recently been completed.

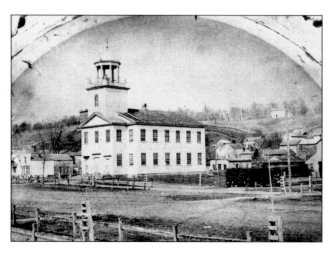

This is a very early photograph of the First Presbyterian Church at 110 West Broadway. It was torn down in the 1860s and replaced by the current building, which was remodeled in 1887. That year, a group of female parishioners decided that a grander building was necessary. They collected $7,500 and hired architect G.W. Hall of Columbus to design the new structure. Exterior changes included new floor-to-ceiling windows and a taller bell tower.

Commissioned by J.S. Jones and designed by Frank Packard, the Granville Inn was one of the most prestigious buildings ever erected in Granville. Completed in 1924, the inn served as a thank-you gift to the village elders, who provided basic sewer, electric, and water treatment services to Granville at the request of Jones. The opening of the Granville Inn was attended by 200 people. They were treated to a buffet and dancing on the terrace and patio. Packard, who also designed the new Granville library that year, died before the inn was completed.

The Granville Public Library was housed in several different locations until 1923, when it finally received a permanent home at 217 East Broadway. Constructed on land donated by Clara Sinnett White, the library took the place of the former Sinnett family home, which was moved to accommodate the new stone building. The Sinnett house was moved once more, in the year 2000, when the library expanded. This block of South Broadway is seen in the 1930s, soon after the library was built and before the post office was constructed.

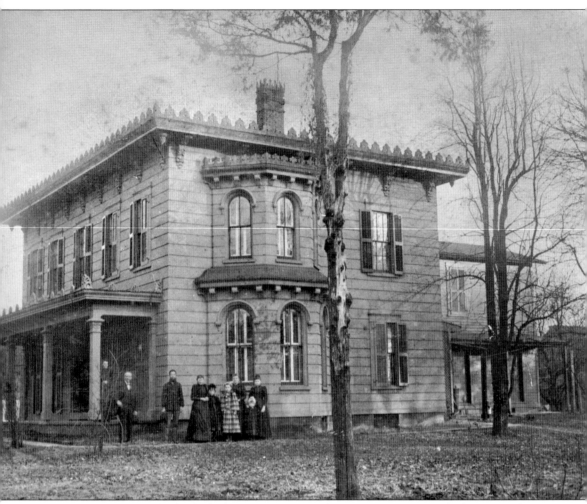

In 1861, George T. Jones built the house at 221 East Elm Street as a present for his new wife. It was constructed in the Italianate style, which was popular at the time. Jones was a prominent businessman in Granville during the second half of the 19th century. He started out as a "tinner" and later opened Jones Hardware. In the early 1900s, the Gregory family took over Jones's store.

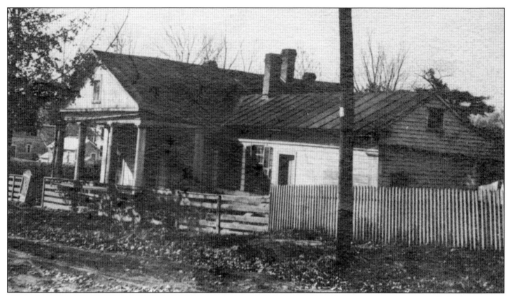

This is a very early photograph of the Elias Gilman house at 200 North Mulberry Street. This structure has the distinction of being the oldest house in town. Built in 1808, it has been used as the Kappa Alpha Theta sorority house since 1929. Gilman was an interesting character. He founded the first school in Granville in 1805 and served as the clerk of Granville and the treasurer of the Congregational Presbyterian Church. He was excommunicated from the church for drinking but remained a prominent member of Granville society. Gilman died in 1857.

The Granville Historical Society has been housed in the former Alexandrian Bank building at 115 East Broadway since 1955. Besides serving as a bank and the historical society's headquarters, the building was once a restaurant and a stop on the interurban transportation system that shuttled passengers between Granville and Newark. This 1952 photograph reveals yet another incarnation of the building, as a barbershop.

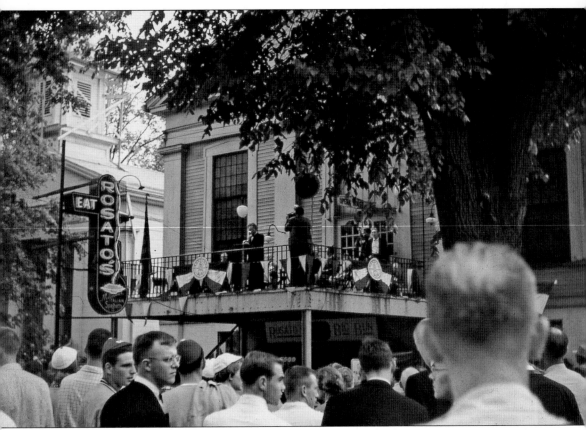

Gov. Frank Lausche speaks to a crowd from the balcony of the Opera House in 1955. Lausche served two terms as governor, from 1945 to 1947 and from 1949 to 1957. He was also the 47th mayor of Cleveland (1941–1944) and a US senator (1957–1969). William T. Utter hosted Lausche on his visit to Granville. The governor attended the opening of the new location of the Granville Historical Society at 115 East Broadway while he was in town. Also of interest in this photograph is the sign for Rosato's restaurant, which was located on the first floor of the Opera House.

SYCAMORE HOUSE.

This house, located at 600 West Broadway, was once known as Sycamore House. It has also been referred to as the Ranch House. Before Denison University had dormitories and fraternity houses on campus, homes in town served as living quarters for students. This house is partitioned into six apartments that were once used for that purpose. The apartments remain inhabited today, but residency is no longer restricted to Denison attendees.

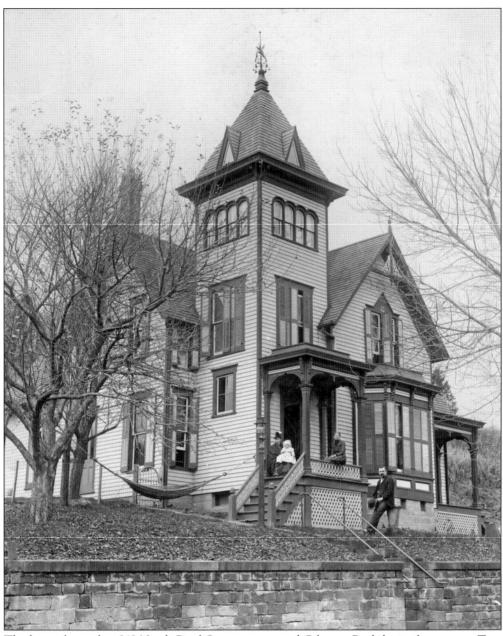

The house located at 343 North Pearl Street was named Cilgwyn Bach by its first owner, Tom Jones. Jones was a veteran of the Civil War and a local gunsmith. The house was built in 1885, and its name means "little white retreat" in Welsh. It has the distinction of being the first structure in town to have a working telephone line. Paul Ramsay, a member of the Presbyterian Church, also owned the house until he died in 1960. It is thus sometimes referred to as the Ramsay Villa. Tom Jones and his family are visible in this photograph from the late 1800s.

North Pearl Street is seen here at the turn of the 20th century. Standing at this location today, one would see Cedar Street to the right and multiple trees and houses. At the time of this photograph, the home of Ashley Bancroft was one of the only structures this far outside of town. Today, as part of Route 661, North Pearl Street connects Granville to the town of Mount Vernon, which is about 40 minutes away by automobile. That trip would have taken hours via this road in 1900.

East Broadway is seen here in the early 1900s. Of particular interest are the interurban tracks that sprawl across the street. The interurban streetcar shuttled passengers between Granville and Newark from 1889 to 1923. The streetcar station was located at 115 East Broadway, the current site of the Granville Historical Society. The interurban made eight round trips per day, running from 5:30 a.m. to 11:30 p.m. As automobiles became popular, the streetcar was no longer necessary. The interurban made its final trip on March 10, 1923, and it whistled all the way to Newark.

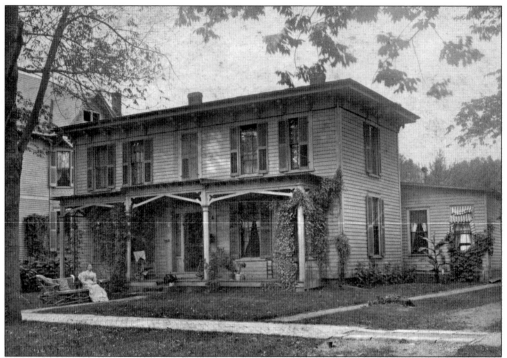

The home at 130 West Broadway looks a bit different now than it did in the late 1800s, as seen here. Today, it is yellow and has a two-story portico attached to its facade. The Italianate-style bracketed cornice has also disappeared. The house was built in 1859 and once belonged to the Eaton family. The home's entrance was built according to plans from a popular pattern book created by an architect named Asher Benjamin. His designs were considered the epitome of the Federal style.

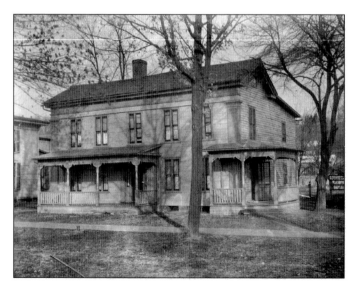

The M. Cline House, located at 128 West Broadway, is seen here at the turn of the 20th century. Cline was an early baker in town, operating out of his house in the 1860s. Other Granville bakers include Clifford Case, George Sapp, J.M. Martin, and George Futerer. The house has gone through some architectural changes over the years. It is now painted blue and has lost both of its porches, but it retains its Greek Revival doorway and cornice.

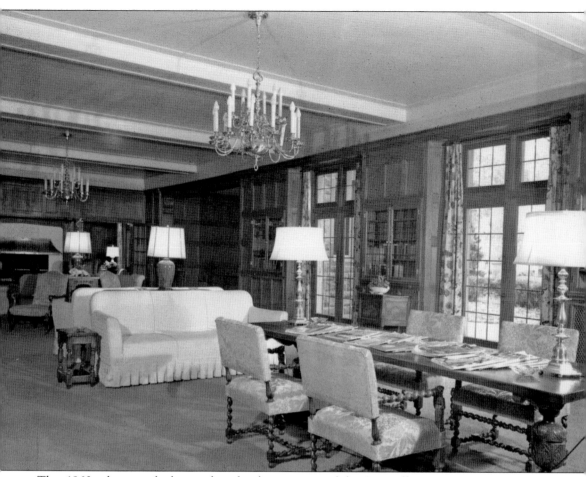

This 1960s photograph shows what the dining room of the Granville Inn once looked like. The inn was designed to be an elegant destination, and no expense was spared in furnishing and decorating the place. The inn opened in 1924 and was managed by Max Mehlborn. The headwaiter in 1925 was named Albin Bratfish, and Maurice Girouax was the inn's French chef. Subsequent chefs included Jean Amingon and Paul Croes. Many groups held dinner parties at the inn. The Granville Golf Club had frequent get-togethers there, and a Newark group called the Granville Inn Dinner Club was formed in the mid-1920s.

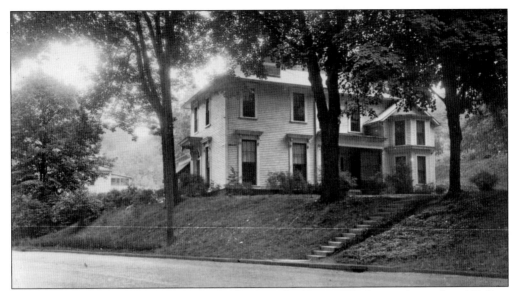

At the base of Mount Parnassus is the Follett-Wright House. The house, located at 403 East Broadway, has operated as a bed-and-breakfast for several years. Built in 1860, the structure was home to Theodore Wright, one of Granville's most successful residents. Wright owned the Granville (flour) Mill, which was sold to the Hulshizer family in 1894. He also owned a cotton plantation in Arkansas. As the head of the Granville Bank in the late 19th and early 20th centuries, Wright became a target for thieves. This home was broken into several times. Wright retired from banking in 1903 and died in 1915. He is buried in Maple Grove Cemetery.

A railroad spur used to stand at Lake Hudson, when the property belonged to the Hammond Sand & Gravel Company. A railroad spur, or branch line, is a secondary track that runs off of the main line. This spur was part of the Toledo & Ohio Central Railroad, which had a stop at 124 South Main Street. It was created so that gravel and sand from the Hammond pits could be loaded into railroad cars on-site. The spur is shown here in the 1930s.

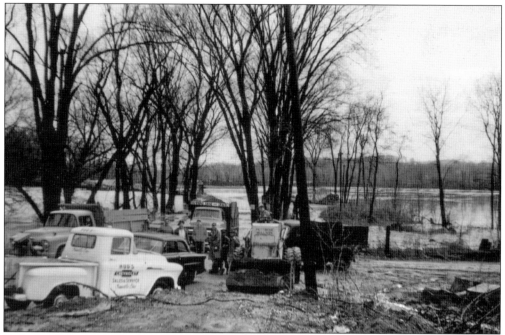

Before patrons could visit Lake Hudson, a beach around the lake had to be created. In this photograph from 1958, the lake's inaugural year, crews are staged and ready to clear out the area that would become the beach. The sand was already in place, left over from the Hammond Sand & Gravel Company, the site's former occupant. The large piles were flattened and spread around to create the beach. As per Hud Williams's plan, Lake Hudson helped beautify the once rural area south of downtown Granville. (Courtesy of Susie Hartfield.)

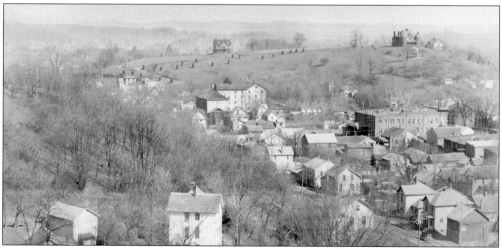

The second house built on top of the hill known as Mount Parnassus (center top) is seen here in the early 1900s. It belonged to John A. McClain, a farmer who raised cattle. From 1876 to 1877, McClain was stationed in Montana and fought against the Sioux Indians, who were trying to hold onto their land. He raised cattle in Wyoming for a time and returned to Granville in 1881. He married in 1885 and bought the lot atop Mount Parnassus in 1889. The *Granville Times* reported that McClain had a huge housewarming party to celebrate his home's completion later that year.

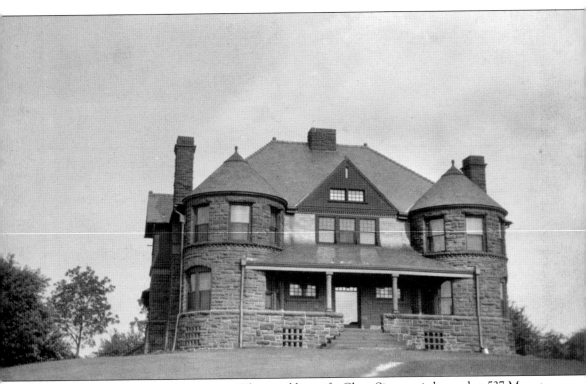

The former home of Charles Brown White and his wife, Clara Sinnett, is located at 537 Mount Parnassus. It was the first home built on top of that hill. The porte cochere that was attached to the front of the home has been removed, but the house looks strikingly similar to the way it did when it was built in 1889. It is now hard to see the front of the house, which faces west and overlooks the town below, because trees have grown up and enclosed the property in woods. This photograph was taken in the early 1900s.

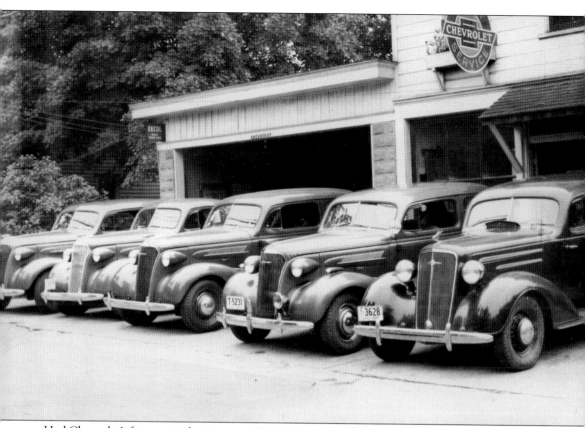

Hud Chevrolet's first year in business was 1937. The original showroom was located in the building at 115 East Elm Street, where Subway is now. The dealership was named after its owner, Luther Hudson "Hud" Williams. Hud started out as a mechanic at a car dealership in Newark called Phalen-Cunningham. He was given the opportunity to start his own mechanic shop at the Elm Street location, and he took it. Chevrolet actually sought out Hud and asked him to become a dealer. Here, cars are on display in front of the new Hud Chevrolet store in 1937. (Courtesy of Susie Hartfield.)

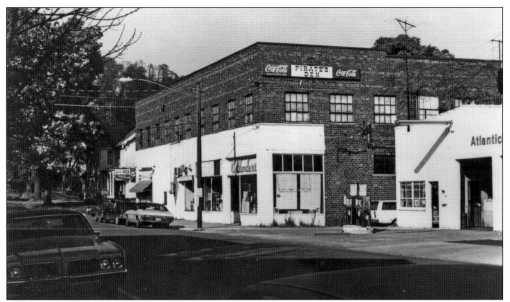

The Pirate's Den was a bar/restaurant that was once housed in the building located at 136 North Prospect Street. The exact location of the establishment is vacant today, but it was also the home of Granvilla Pizza until 2003. Current businesses in the Pirate's Den building include Village Tanning and Greek Eats. This photograph from the late 1960s shows what the building looked like when the storefronts were painted white.

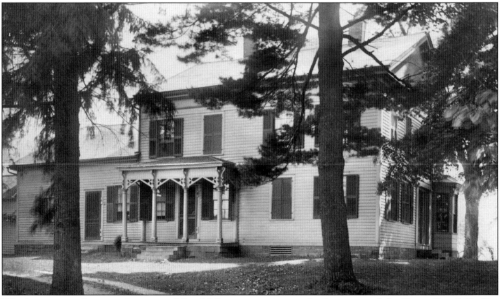

The house seen here at the turn of the 20th century is now the location of the River Road Coffee House. The structure was originally located on South Main Street, not far from the River Road intersection. It belonged to members of the Hillyer family. Justin Hillyer was one of the first settlers in Granville. He was an abolitionist, owned a gristmill, and once got in trouble for working on a Sunday, which was a serious offense at the time. His daughter Orlena was thought for a long time to be the first child born to the settlers. Other Hillyers included Virgil, a smokehouse owner, and Horace, a member of the Granville gold seekers who went west during the 1849 Gold Rush.

BIBLIOGRAPHY

Bushnell, Rev. Henry, A.M. *The History of Granville: Licking County, Ohio.* Columbus, OH: Press of Hann & Adair, 1889.

Lisska, Anthony. "The Newark-Granville Interurban Car: Was it the First Interurban in the Country?," *The Historical Times* V, no. 1 (1991): 3.

Utter, William T. *Granville: The Story of an Ohio Village.* Granville, OH: Granville Historical Society, 1956.

www.granville.oh.us

www.denison.edu

Discover Thousands of Local History Books
Featuring Millions of Vintage Images

Arcadia Publishing, the leading local history publisher in the United States, is committed to making history accessible and meaningful through publishing books that celebrate and preserve the heritage of America's people and places.

Find more books like this at
www.arcadiapublishing.com

Search for your hometown history, your old stomping grounds, and even your favorite sports team.

Consistent with our mission to preserve history on a local level, this book was printed in South Carolina on American-made paper and manufactured entirely in the United States. Products carrying the accredited Forest Stewardship Council (FSC) label are printed on 100 percent FSC-certified paper.

MADE IN THE **USA**